BRENT LIBRARIES

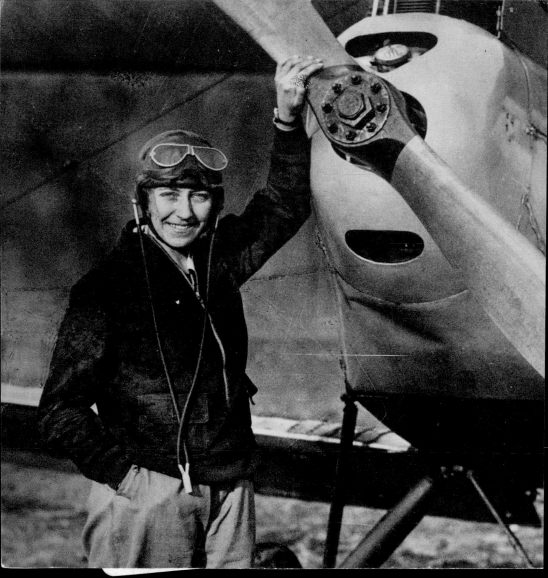

NATIONAL PORTRAIT GALLERY

100
PIONEERING WOMEN

CONTENTS

PAGE 2 OPPOSITE

AMY JOHNSON
MARY SEACOLE
Published by Raphael Tuck & Sons, 1930
Albert Charles Challen, 1869
Detail from portrait on page 94
Detail from portrait on page 67

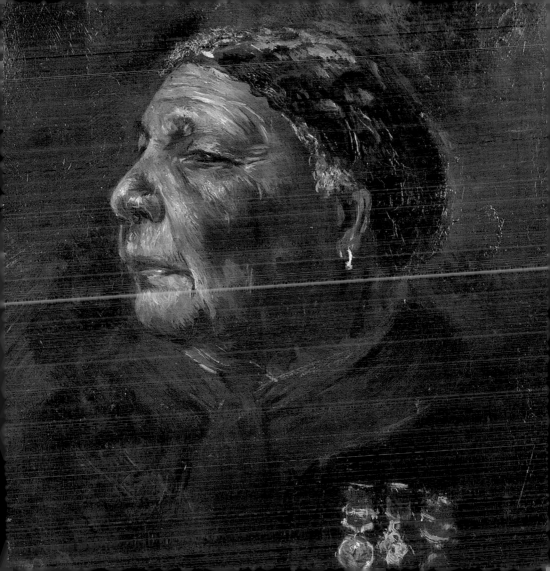

INTRODUCTION
LUCY PELTZ

When the National Portrait Gallery was founded, in 1856, women didn't have the vote and couldn't stand for office. Few managed to have careers. Although some did work, their options were limited. In domestic life, there was little contraception, and giving birth was often fatal. A married woman's property, including her earnings, belonged to her husband. Every divorce required an Act of Parliament.

In these circumstances, it's not surprising that there were no women among the Gallery's founders. Yet, in its earliest days, women could be found on the Gallery's walls, alongside so many male judges, politicians, monarchs and artists. All had been judged equally worthy of recognition for their contributions to British culture and society, answering the tenets of an institution conceived as a gallery 'of portraits of the most eminent persons in British history'.

The Prime Minister, Lord Palmerston, had supported the Gallery's foundation, stating that it would be 'a great gratification to see the likeness of men whose actions have excited our admiration'. He asserted that there could be 'no greater incentive to mental exertion, noble actions or good conduct' than to see 'the features of those who have done things which are worthy of

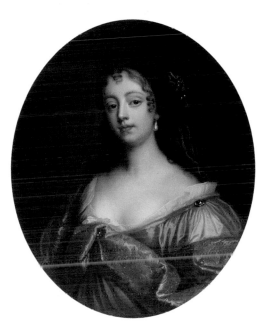

ELIZABETH HAMILTON,
COUNTESS OF GRAMONT (1641–1708)
John Giles Eccardt, after Sir Peter Lely, oil on canvas, eighteenth century, based on a work of c.1663. NPG 20

our admiration and whose example we are more minded to imitate when they are brought before us in the visible and tangible shape of portraits'.[1] With portraits thereby treated as an unproblematic way into a life, the foundation of the Gallery was situated

in the Victorian rhetoric of nationalism, self-improvement and patriarchy.

Portraits, whether of men or women, came to the Gallery because of the subject's contribution to British history. Despite the hope that these portraits would serve as examples for inspiration and emulation, the Trustees were clear that 'great faults and errors' were no cause for excluding a subject who had played a significant part in the national narrative.[2]

Whatever these intentions, the Collection was initially more 'pick and mix' than 'picture of the nation'. In 1863, Charles Dickens analysed the nascent collection – at that time comprising some 164 portraits. He advised his readers that the largest group was politics and diplomacy, with thirty-nine portraits, followed by literature, with twenty-nine, and the clergy, with twenty-five. Drilling down further, and choosing occupations at random, he noted that there were seven lawyers, six naval heroes, four engineers, three 'great revolutionists' and one musical genius.[3] Dickens, however, failed to mention the women who had already entered the Collection – fifteen by 1863. Although small in number, this shows that the female contribution to the nation's history was publicly acknowledged from the outset.

Reflecting the vagaries of the market and the availability of portraits, the first painting of a woman to arrive was that of the racy Elizabeth Hamilton, Countess of Gramont, a Restoration courtier most notable for her wit and beauty. Indeed, the acquisition excited the Gallery's critics, with the *Art Journal* asking humourlessly whether 'La Belle Hamilton is the sort of Person whom "Parliament intended that the trustees should offer to the working public as one of the first and most illustrious examples of British worth."'[4]

By contrast, the second woman in the Collection presented an excellent role model for the Victorian woman. Thomas Lawrence's pastel shows the elderly writer and scholar Elizabeth Carter with an averted gaze, reflecting her known concern for modesty and privacy. The pose befitted a genteel and pious eighteenth-century woman, and did nothing to signal Carter's intellectual achievements and published status. In the 1750s, Carter and her friend, the literary critic Elizabeth Montagu, helped to establish the Bluestocking Circle, a space for intellectual conversation around literature and ideas. Nurturing friendship, conversation and patronage, Bluestocking women formed social networks to overcome some of the prejudices and constraints that pioneering female writers,

artists and thinkers were experiencing. (Another portrait of Carter, painted in her youth, is reproduced on page 37.)

The word 'Bluestocking', describing a literary or learned woman, has a curious history. First coined in the eighteenth century, its shifting meaning reveals the changing attitudes towards women. Today the term might be used in a disparaging sense, to suggest a certain type of bookish and dowdy woman. Conversely, others claim it as a positive term connected to a tradition of feminist pioneers. The ambivalence surrounding the word reflects society's perennial anxiety about female achievement, too often regarded with suspicion rather than admiration. This was not the case in the mid-eighteenth century, when growing cultural, commercial and national confidence helped shape the popular perception both of the Bluestocking Circle and of accomplished women more generally. For the first time, the creative and intellectual woman was celebrated. Moreover, she was accorded a patriotic identity as an emblem of Britain's sense of refinement and international superiority.[5]

The idea of Britain's artistic and intellectual women was triumphantly promoted by Richard Samuel in an unusual group portrait exhibited at the Royal Academy in 1779. It depicts nine contemporary creative women

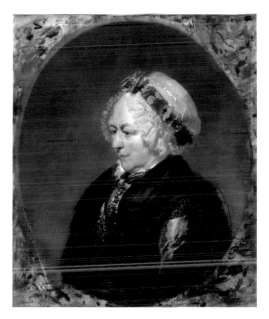

ELIZABETH CARTER (1717–1806)
Sir Thomas Lawrence, pastel on vellum, 1788–9. NPG 28

dressed in classicising robes as 'the Characters of the Muses in the Temple of Apollo'. A gathering of writers, scholars, artists, actors and musicians, each of the chosen women – with the exception of the Bluestocking hostess, Elizabeth Montagu – earned a living from her work. By representing real women as the symbolic figures of the Muses, Samuel's composition extols the contribution of female

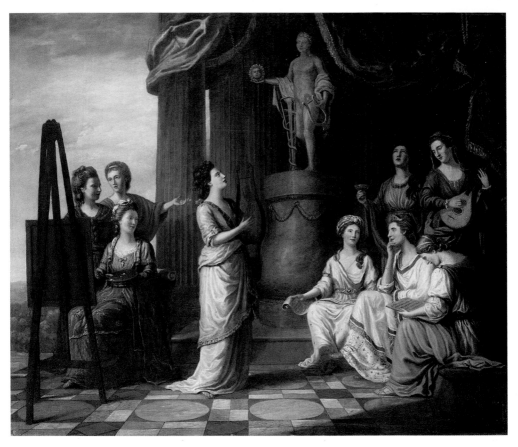

PORTRAITS IN THE CHARACTERS OF
THE MUSES IN THE TEMPLE OF APOLLO
Richard Samuel, oil on canvas, 1778. NPG 4905
Group at left (left to right): Elizabeth Carter
(1717–1806), Anna Letitia Barbauld (1743–1825),
Angelica Kauffmann (1741–1807). Middle: Elizabeth
Sheridan (1754–92). Group at right, seated (left to right):
Elizabeth Griffith (1727–93), Elizabeth Montagu (1718–
1800), Catharine Macaulay (1731–91); standing: Hannah
More (1745–1833), Charlotte Lennox (1720–1804).

professionals to the 'sister arts' and to Britain's international standing. An engraving based on the painting, titled *The Nine Living Muses of Great Britain*, capitalised further on the popular interest in a new phenomenon – that of the learned, artistic and professional woman.

Among Samuel's muses was Catharine Macaulay (1731–91), presented as Clio, Muse of History. One of the leading political activists of the time, Macaulay's eight-volume *History of England* (1763–83), and various political tracts, contributed to the Opposition's radical programme for political reform and their support for American independence. While her *History* was widely admired, all critics, whatever their politics, marveled at the 'masculine force' of her writing. Fellow Radicals praised her as a 'Female Cicero', while conservatives condemned her as a 'virago' – a woman who acts with the power and manner of a man.[6] Unlike most female authors of the day, Macaulay was not self-effacing or publicity shy. The unflinching portrait on page 41, painted at the outset of the American War of Independence in 1775, underlines her commitment to representative government. She is shown wearing the sash of an elected Roman senator, and leans on a plinth inscribed: GOVERNMENT/A POWER DELEGATED/FOR THE HAPPINESS/OF/MANKIND.

If radical politics, widowhood and a group of ardent followers, encouraged Macaulay to adopt unfamiliar roles, her eventual fall from grace resulted from the changing political landscape and, concomitantly, a new public focus on her contempt for the norms of polite female behaviour. It was not just her contribution to the supposedly masculine arenas of history and politics but also her rushed second marriage to a poorly educated man less than half her age that exposed her to accusations of licentiousness. While the scandal around her personal life compromised Macaulay's reputation, it did not stop her writing. Her *Letters on Education* (1790), which argued for parity in the education of girls and boys, and *Observations on the Reflections of The Right Hon. Edmund Burke* (1790), a riposte to Burke's conservative diatribe against the Revolution in France, attracted the attention of a young Mary Wollstonecraft (1759–97; see page 42), whose first publication was *Thoughts on the Education of Daughters* (1787). Wollstonecraft wrote an impassioned letter to Macaulay, claiming her as a kindred spirit: 'You are the only female writer who I consider in opinion with respecting the rank our sex ought to attain in the world. I respect Mrs Macaulay … because she contends for laurels whilst most of her sex only seek for flowers.'[7]

Several liberal thinkers of the 1790s commented on women's lack of equality – with hardly any legal rights, unable to own property and at the mercy of men for their survival. However, only Wollstonecraft, in her political writing, called uncompromisingly for the rights of women to full citizenship, including the right to education. In *Vindication of the Rights of Woman* (1792), she asserted: 'It is time to effect a revolution in female manners – time to restore [women] their lost dignity – and make them, as part of the human species, labor by reforming themselves to reform the world.' Wollstonecraft is now considered the founder of modern British feminism, but women's road to liberty and equality was not straightforward. In the wake of the American and French Revolutions there was a profound reaction against the intelligent and socially engaged woman, who came to be perceived as a threat to the social order. No doubt fuelled by the spectre of women marching on the streets of Paris, the prominence of so many intelligent and engaged women was no longer greeted as a mark of a civilised society but one to be treated with suspicion and disgust.

The Evangelical educationalist Hannah More – another of Richard Samuel's 'muses' – also believed that proper education was necessary to make women more useful and productive members of society (see page 50). Refuting Wollstonecraft's premise of equality between men and women, she argued that the sexes occupied separate spheres by nature as well as by custom. Men, she proposed, were 'naturally formed for the more public exhibitions of the great theatre of human life'. Women, in contrast, 'possess ... delicacy and quickness of perception and nice discernment'. From More's perspective, women were best suited to seeing the world as if from 'a little elevation in her own garden'.[8] The language is indicative – resulting from biological predetermination, More's ideal woman was a gentler, domestic being. Female readers of her educational tracts were advised to accept their frailty and inferiority and were warned against an 'impious discontent with the post to which God has assigned them'. In More's estimation, however, women were not rendered socially impotent by this. The combination of rational education, chaste morals and religious devotion that she encouraged was meant to help young middle-class women attract virtuous husbands and fulfill their duty towards improving their menfolk and raising God-fearing children. In consequence, More called on women to use their influence for

the national good, as agents of philanthropic action. As the nineteenth century unfolded, such philanthropy was the most common form of female activism.

Despite the earlier advances that had seen empowered women entering the cultural public sphere, the second half of the nineteenth century witnessed a reassertion of women's domestic vocation. This was famously praised by Coventry Patmore in his poem *The Angel in the House* (1854), which presented a popular vision of his devoted wife as the symbol of ideal womanhood: passive, graceful, self-sacrificing and, above all, pure. Unsurprisingly, Patmore's 'angels' were focussed on a life of service to their children and husbands. For many, such a relentlessly domestic image of womanhood was suffocating and repressive, destroying any sense of vocational or professional potential. As Virginia Woolf (see page 83) wrote in a lecture delivered to the Women's Services League and titled *Professions for Women* (1931), 'killing the Angel in the House was part of the occupation of a woman writer'. The poet Elizabeth Barrett Browning complained: 'England has had many learned women ... and yet where are the poetesses? ... I look everywhere for grandmothers, and see none.'[9] Barrett Browning's frustration at the

apparent lack of real precursors she could draw upon for inspiration lends weight to an observation of Germaine Greer (see page 133), who rose to prominence as a major voice for women's liberation following the publication of her bestselling book *The Female Eunuch* (1970). In an article of 1974, Greer noted 'the phenomenon of the transience of female literary fame', describing the recurrent historical pattern whereby 'a small group of women have enjoyed dazzling prestige during their own lifetimes, only to vanish without a trace from the records of posterity'.[10] It is in the face of this phenomenon that professional women have struggled to forge a sense of continuity, to assert a consciousness of their sex and its achievements in cultural and historical terms.

In the National Portrait Gallery's ongoing mission to make the Collection representative of Britain, past and present, Curators and Trustees – the majority of whom currently are women – consciously try to develop the collection of female portraits. For modern and contemporary this is a straightforward activity; but for the historical collection it involves understanding what might constitute female achievement in any given period. From Lady Anne Clifford (see page 29), who fought tirelessly for what was rightfully hers

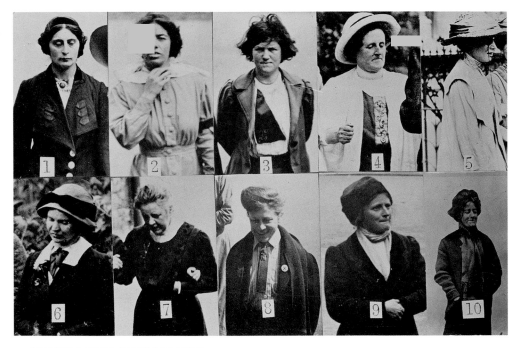

SURVEILLANCE PHOTOGRAPHS OF MILITANT SUFFRAGETTES

Criminal Records Office, gelatin silver print mounted on identification sheet, 1914. NPG x132846

Surveillance photographs of militant suffragettes were issued to public galleries, including the National Portrait Gallery in 1914. Most of the photographs show women serving sentences in Holloway and Manchester, and were taken undercover in prison exercise yards. This example shows: 1. Margaret Scott (1888–1983); 2. Olive Leared (1881–1936); 3. Margaret McFarlane (1888–?); 4. Mary Wyan (Mary Ellen Taylor) (1864–1914); 5. Annie Bell (1874–?); 6. Jane Short (1882–?); 7. Gertrude Mary Ansell (1861–1932); 8. Maud Mary Brindley (1866–?); 9. Verity Oates (dates unknown); 10. Evelyn Manesta (1888–?)

and thereby consolidated her family property and status, in the seventeenth century, to Nicola Adams (see page 156), whose career as a woman boxer, in the twenty-first century, was only made legal by a Parliamentary vote that lifted a ban that had stood for over a century. Or Emmeline Pankhurst (see page 91), who, like the women pictured opposite, fought for suffrage for British women in the early twentieth century, to Barbara Castle (see page 131), a politician whose most enduring achievements – the Equal Pay Act 1970, pension reforms and the introduction of child benefit, among them – provided important milestones on the road to equality.

The women in the National Portrait Gallery's Collection have made their mark in a wide variety of areas: from politics to medicine,

science to the arts, commerce to sport, women's arenas for achievement and the possibilities of portraiture are constantly evolving and are documented in the selection of the 100 'greats' featured in the pages that follow.

LUCY PELTZ
Senior Curator of Eighteenth-Century Collections

In writing this essay, I acknowledge my debt to the work of Elizabeth Eger on the exhibition Brilliant Women *(2008), and the help of Christopher Tinker*

NOTES

1 Hansard, Commons, 6 June 1856, colls 113–24, quoted in David Cannadine, *National Portrait Gallery: A Brief History* (National Portrait Gallery, London, 2007), p.17.

2 Ibid.

3 Charles Dickens, 'National Portraits', *All the Year Round*, 7 November 1863, pp.252–6 (p.252).

4 *The Art Journal* (1859), quoted in M. Pointon, *Hanging the Head: Portraiture and Social Formation in Eighteenth-Century England* (1993), p.235.

5 For a full discussion of this see Elizabeth Eger and Lucy Peltz, *Brilliant Women: Eighteenth Century Bluestockings* (National Portrait Gallery, London, 2008).

6 Letter from Edmund Burke to Richard Shackleton, n.d.

(before 15 August 1770), in Lucy S. Sutherland, *The Correspondence of Edmund Burke*, 6 vols (Cambridge, 1958–67), II, p.150.

7 Letter from Mary Wollstonecraft to Catharine Macaulay, 16 or 23 December 1790, MS MW47. The Carl H. Pforzheimer Collection of Shelley and His Circle. The New York Public Library, Astor, Lenox and Tilden Foundation.

8 Hannah More, *Strictures on the Modern System of Female Education* (1799), I, pp.21, 23 and 27.

9 *The Letters of Elizabeth Barrett Browning*, ed. Frederick G. Kenyon, 2 vols (NY, 1899), I, pp.230–2.

10 Germaine Greer, 'Flying Pigs and Double Standards', *TLS*, 26 July 1974, p.784.

100 PIONEERING WOMEN

OPPOSITE
KATHERINE PARR
Attributed to Master John, c.1545
Detail from portrait on page 20

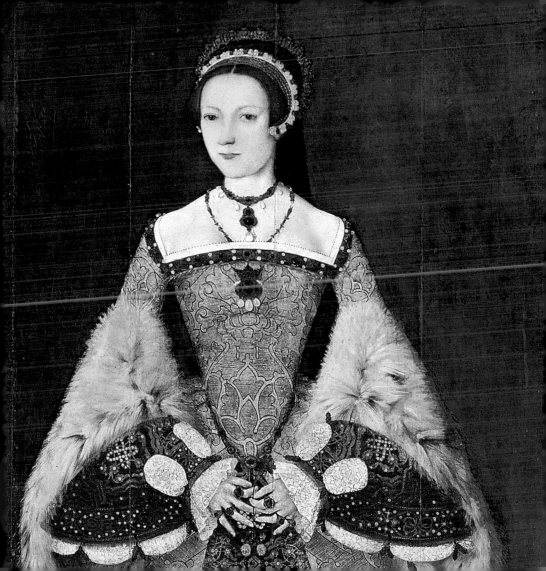

LADY MARGARET BEAUFORT, COUNTESS OF RICHMOND AND DERBY

Unknown artist, second half 17th century

Oil on panel, 686 x 549mm • NPG 551

Medieval noblewoman Lady Margaret Beaufort
(1443–1509), the mother of Henry VII, was
central to ensuring his kingship. She married
(in 1454/5, and later twice more) and was
widowed in 1456, just before the birth of Henry,
her only child. A woman of substance, devout
and determined, she proved adept at political
intrigue, consolidating the Tudor dynasty and
her own influence. She was, for instance, the first
woman to have her own council, at Collyweston,
a seat of justice empowered to settle disputes.
'Right studious she was in books', too, according
to Bishop Fisher, and a pioneering patron of
scholarship and learning. She founded St John's
College, Cambridge, the charter of which was
sealed by her executors in 1511, and, with a
royal charter from her son, re-founded Christ's
College, Cambridge, in 1505. Around 1502, she
created England's first endowed professorships,
the Lady Margaret professorships of divinity. She
also commissioned works of literature and music,
and translations of religious texts. Lady Margaret
Hall, which was founded in 1878, pioneered the
opening up of Oxford to women and is named
after her, a friend to 'poor scholars'.

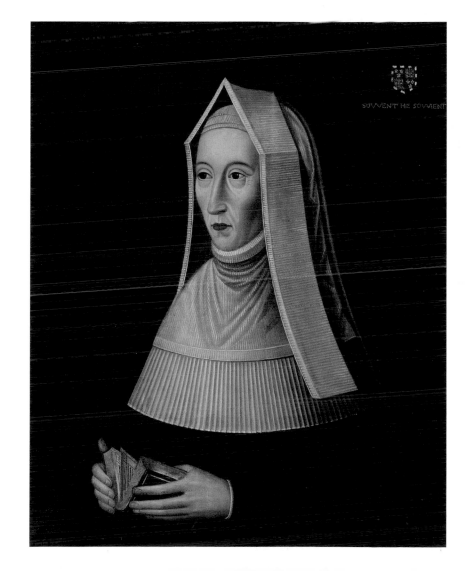

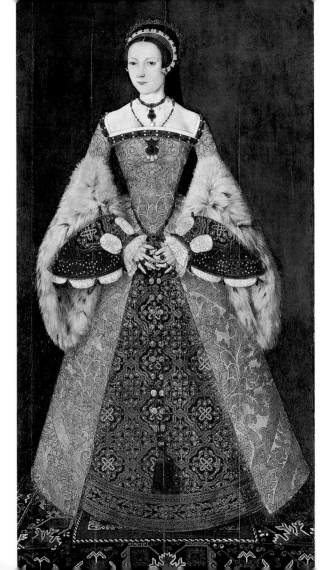

KATHERINE PARR

Attributed to Master John, c.1545

Oil on panel, 1803 x 940mm • NPG 4451

Katherine Parr (1512–1548) was Henry VIII's sixth wife and the only one of his queens without either a royal background or previous court service when she married him. When, in 1544, the King led a military expedition to France, he appointed Katherine as regent-general and she presided, to the displeasure of some, over the regency council and ruled in the King's name. She was a patron of the King's printer, Thomas Berthelet, and promoted the art of bookbinding with her orders for books in stamped leather, coloured velvets and enamelled gilt. She was also heavily involved in educational patronage and seems to have played a part in the publication of a reading primer for children (1544–5), and influenced her husband in the foundation of Trinity College, Cambridge. In 1545, she published *Prayers or Meditations*, which featured five of her original prayers, including one for men going into battle. It was the first work ever published by an English queen.

QUEEN MARY I

Hans Eworth, 1554

Oil on panel, 216 x 169mm • NPG 4861

Mary I (1516–58) was England's first queen regnant. She ruled as Queen of England and Ireland from July 1553 until her death in November 1558. The only child of Henry VIII and Katherine of Aragon to survive into adulthood, she (and her mother) gradually fell out of favour with the King. The Succession Act of March 1534 formally declared Mary illegitimate, elevating Anne Boleyn's children as heirs to the throne. Mary was restored to the line of succession, behind her half-brother Edward, in 1544, following an improvement in familial relations over the course of Henry VIII's sixth marriage, but was subsequently excluded from the line of succession in Edward VI's will, primarily due to her religious convictions. Nevertheless, Mary had widespread popular support and deposed Lady Jane Gray as queen in 1553 after just nine days. Once queen, she sought to re-impose Catholicism and her persecution of Protestants earned her the posthumous sobriquet 'Bloody Mary'.

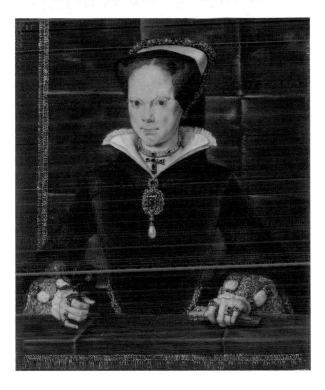

QUEEN ELIZABETH I

Unknown English artist, c.1588

Oil on panel, 978 x 724mm • NPG 541

Elizabeth I (1533–1603) was the only child of
Henry VIII and his second wife, Anne Boleyn.
She spent a number of months in the Tower of
London during the reign of her half-sister Mary
I, on suspicion of having played a role in the Wyatt
rebellion of 1554. She ascended to the throne
on 17 November 1558 and her forty-four-year
reign was characterised by relative peace and
prosperity and the transformation of the English
language through a thriving literary culture.
She did not marry, although she had many suitors.
When, in 1588, the Spanish Armada, a fleet of
130 vessels, threatened (unsuccessfully) to
invade the southeast of England, Elizabeth I
joined her troops at Tilbury and delivered her
most famous speech: 'I know I have the body
but of a weak and feeble woman; but I have
the heart and stomach of a king, and of a king
of England too.' This portrait was painted to
commemorate that conflict.

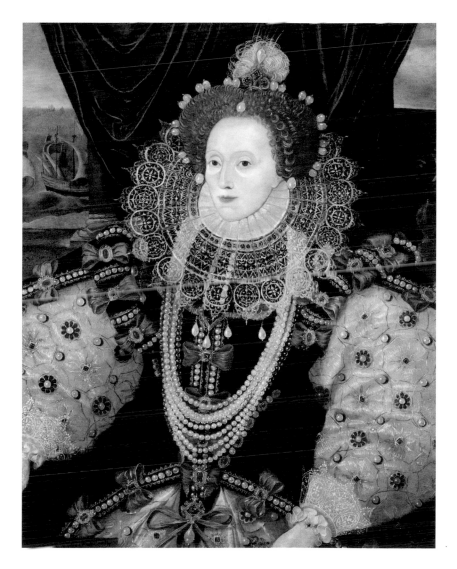

MARY HERBERT, COUNTESS OF PEMBROKE

Nicholas Hilliard, c.1590
Watercolour on vellum, 54mm diameter
• NPG 5994

Mary Sidney (1561–1621), the younger sister of Philip Sidney, was one of the first English women to achieve a major reputation for her poetry and literary patronage. As a child, she received a humanist education and became fluent in French, Italian and Latin. She collaborated with, and encouraged, her brother in his writing, and after his death became a noted supporter of the writers to whom he had acted as patron. Herbert supervised the 1593 and 1598 editions of her brother's *Arcadia*, and completed the paraphrasing of the Psalms that he had begun. *Antonius*, her translation of Robert Garnier's *Marc Antoine*, was the first dramatisation of the story of Antony and Cleopatra in England, and one of the first English dramas in blank verse.

ELIZABETH TALBOT ('BESS OF HARDWICK'), COUNTESS OF SHREWSBURY

Unknown artist, probably seventeenth century, based on a work of c.1590

Oil on canvas, 988 x 787mm • NPG 203

'Bess of Hardwick' (*c*.1527–1608) was one of the richest people in late Elizabethan England, and an important patron of architecture. Bess came from a modest background, but rose to a position of power and moved in aristocratic and royal circles. She acquired her wealth through a succession of increasingly profitable marriages and through her own business acumen. Hardwick Hall, the country house she had built in Derbyshire to a plan by the Elizabethan architect Robert Smythson, was, according to an inventory of 1601, filled with a collection of paintings, furniture, silver, tapestries and embroidery. The nearby estate of Chatsworth was acquired during her second marriage to Sir William Cavendish, and was held in both their names. Following Sir William's death, Bess continued to oversee the ambitious building project they had begun together.

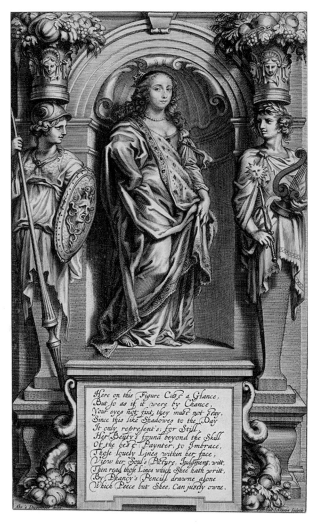

MARGARET CAVENDISH, DUCHESS OF NEWCASTLE UPON TYNE

Pieter Louis van Schuppen, after Abraham Diepenbeeck, c.1655–8
Line engraving, 371 x 222mm
• NPG D11111

Margaret Cavendish (1623?–74) was a prominent aristocrat and an attendant of Queen Henrietta Maria. A poet, philosopher, essayist and playwright, she published under her own name, and her work addressed a wide range of subjects, including gender and sex, power, science and philosophy. In 1667, she became the first woman to attend a Royal Society demonstration, and engaged with, and wrote critiques of, the writings of René Descartes and Thomas Hobbes, among others. In 1666, and again in 1668, she published *The Description of a New World, called the Blazing-World*, considered by critics today to be an early pre-cursor to science fiction. Cavendish was regarded by her contemporaries as a character, with an eccentric sense of style and speech full of 'oaths and obscenity'.

ANNE, COUNTESS OF PEMBROKE (LADY ANNE CLIFFORD)

William Larkin, c.1618

Oil on panel, 575 x 435mm • NPG 6976

Anne Clifford (1590–1676) was the only surviving child of George Clifford, third Earl of Cumberland, and his wife, Lady Margaret. She became famous for fighting a long legal battle over what she believed to be her rightful inheritance: the estates in Westmorland and Yorkshire that her father bequeathed to his brother in 1605. Among the many milestones in her fight was her refusal, in 1617, to accept a settlement of £17,000 to resolve the dispute and agree that all the estates should be retained by her uncle and his male heirs. It was only in 1643, after the death of her cousin, that Anne regained the Clifford family estates and she subsequently dedicated herself to restoring and enhancing the castles and churches on her lands. A diarist and writer, she also commissioned numerous portraits, including two large triptychs, and works of family history. At her death, she was probably the wealthiest noblewoman in England.

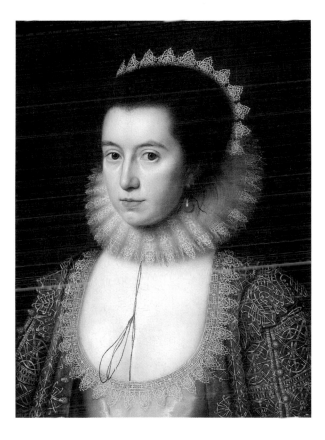

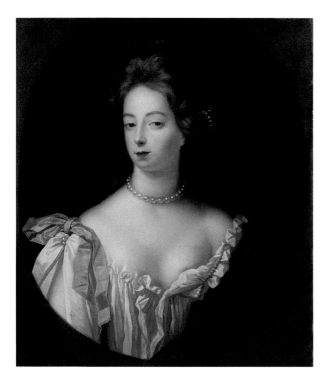

NELL GWYN
Simon Verelst, c.*1680*
Oil on canvas, 737 x 632mm • NPG 2496

On 1 May 1667, diarist Samuel Pepys wrote, 'Up, it being a fine day: and after doing a little business in my chamber, I left my wife to go abroad ... and saw pretty Nelly standing at her lodgings door in Drury-lane in her smock-sleeves and bodice.' Pretty Nelly was Eleanor 'Nell' Gwyn (1651?–87), one of the first actresses on the public stage. She was also Charles II's self-proclaimed 'Protestant whore', the best-known royal mistress in English history. Most likely born in London, Gwyn grew up in its slums in the shadow of civil war. She never knew her father. Her mother, who drank to excess, died by drowning. Gwyn, however, eternally irreverent and an inveterate optimist, embodied the Restoration spirit. After living hand-to-mouth, selling oranges and shucking oysters, she established herself as a comic actress in London's Drury Lane. It was a role that she enacted, too, in the Carolean court, her wits as much as her looks ensuring her favour there.

MARY BEALE
Self-portrait, c.1666
Oil on canvas, 1092 x 876mm • NPG 1687

Mary Beale (1633–99) is a rare example of a
seventeenth-century woman who succeeded as
a professional artist. Supported by her husband
Charles, whose own employment was insecure,
she set up a professional studio practice, having
previously provided supplemental income for
her family by painting mainly for friends. Charles
acted as her studio manager and assistant, and
his notebooks recording commissions, sittings,
payments and other incidental information are
an important source of information about studio
practice at the time. She was one of four female
artists included in William Sanderson's *Graphice
… or, The most Excellent Art of Painting* (1658) and
also wrote an 'Essay on friendship', in which
she sets out the notion – radical for the time –
of equality between men and women, in both
marriage and friendship.

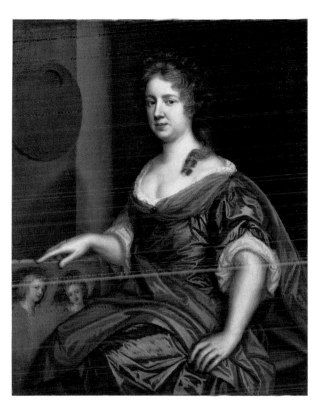

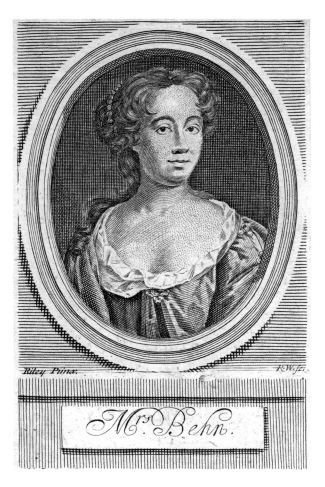

Ridey Pinx. R.W.fc.

Mrs Behn.

APHRA BEHN
Robert White, after John Riley, published 1716
Line engraving, 130 x 86mm (paper size)
• NPG D9483

According to Virginia Woolf, in *A Room of One's Own* (1929), 'All women together ought to let flowers fall upon the tomb of Aphra Behn ... for it was she who earned them the right to speak their minds.' Aphra Behn (1640–89) was one of the first English women to earn her living by writing (seventeen plays, numerous poetry collections and translations, and thirteen novels, including *Oronooko* (1688), her anti-slavery novel) – quite a feat in the male bastion of literary Restoration England. Her other achievements are legion: political activist, sexual pioneer, an early abolitionist, a spy (against the Dutch, for Charles II), a feminist and an adventurer. Living as she did in the seventeenth century, with no inherited status or wealth, and, moreover, as a woman, hers was an exceptional life. Yet, while her associate and contemporary John Dryden lies in Poets' Corner at Westminster Abbey, Behn's memorial is to be found in the east cloister, outside.

ANNE FINCH, COUNTESS OF WINCHILSEA

Peter Cross, c.1690–1700
Watercolour on vellum and card,
76 x 64mm • NPG 4692

Anne Finch (1661–1720), acquaintance
and contemporary of fellow Augustan poet
Alexander Pope, is best known for her Pindaric
ode and longest poem, *The Spleen* (1701), and
for *Miscellany Poems, on Several Occasions* (1713).
By the nineteenth century, William Wordsworth
and other Romantics had come to see her as a
kindred spirit. In the preface to *Lyrical Ballads*
(1815), Wordsworth described her as one of the
few Augustan poets to use 'gentle imagination'
to describe 'external nature'. She is among the
first female poets ever published, writing not
just verse but also prose and plays, all amid the
difficulties of a woman navigating the male-
dominated literary world. Born in Hampshire,
daughter of Sir William Kingsmill, Finch was not
only aristocratic but educated, too, her family
being proponents of schooling for girls. A 'gentle
fighter' is how twentieth-century poet Dilys
Laing described her; a great advocate of social
justice for women. She became Countess of
Winchilsea in 1712, when her husband, Heneage
Finch, became 5th Earl of Winchilsea.

LADY MARY WORTLEY MONTAGU

Attributed to Jean Baptiste Vanmour, c.*1717*

Oil on canvas, 693 x 909mm • NPG 3924
(This detail, showing Lady Mary with her son,
Edward, is from a work that also features two
attendants – see inset)

Lady Mary Wortley Montagu (1689–1762) was a
dazzling figure of the Augustan age, an aristocrat,
traveller, letter-writer and poet. With no formal
education, she nonetheless read widely from her
father's library and even taught herself Latin.
A peer's daughter, said to be a great beauty, she
eloped in 1712 with Edward Wortley Montagu;
when he became ambassador to Turkey in
1716, she joined him there, dispatching letters
home. These Turkish Embassy *Letters* (1763)
drew acclaim from the great writer–philosopher
Voltaire, esteemed historian Edward Gibbon and
others, praising her wit, intellect and culture.
They are also notable for her feminist stance.
Lady Mary was one of the first female political
journalists, too, producing, among other works,
a periodical, *The Nonsense of Common Sense*,
that backed Robert Walpole's government.
Known not only for her sparkling intellect and
connections (with Alexander Pope and his circle,
for instance), she also introduced smallpox
inoculation to Britain, despite opposition from
the medical establishment.

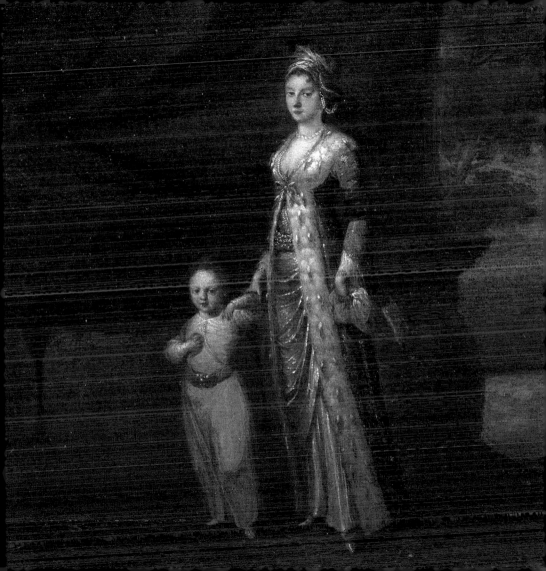

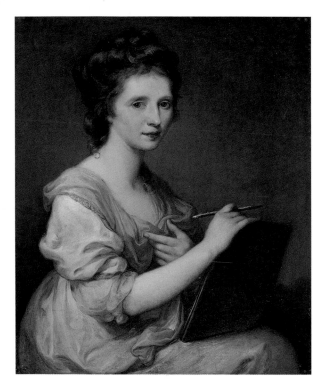

ANGELICA KAUFFMANN
Self-portrait, c.*1770–5*
Oil on canvas, 737 x 610mm • NPG 430

Swiss Neoclassical painter Angelica Kauffmann
(1741–1807) was one of two female founder-
members (1768) of the Royal Academy of Arts
(RA), London (the flower painter Mary Moser
was the other). She achieved this when women
were generally marginalised from the visual arts.
Kauffmann's father (like Moser's) was an artist,
Johann Joseph Kauffmann, who guided his
daughter's precocious talent. She spent time in
Italy, specialising in history and portrait painting,
and joining the Accademia di San Luca, Rome,
in 1764. Her portrait of the German art historian
Johann Joachim Winckelmann of 1764 brought
her international attention. In London, between
1766 and 1781, she enjoyed continuing patronage
and support from King George III, among other
notables – including Joshua Reynolds, then
Britain's most influential painter and first president
of the RA. However, Kauffmann's trailblazing
was tempered by the treatment given to her and
Moser in Johan Zoffany's *The Academicians of the
Royal Academy* (1771–2). Unlike the men, who
are depicted in person, the women feature only
as portraits hanging on the wall – reflecting
the fact that they were not allowed inside
life-drawing classes, which that painting depicts.

ELIZABETH CARTER AS MINERVA
John Fayram, c.1735–41
Oil on canvas, 900 x 690mm • NPG L242

Elizabeth Carter (1717–1806), poet, translator
and writer, first became acquainted with her
contemporary Dr Samuel Johnson via her
contributions to the *Gentleman's Magazine*.
It was the start of a friendship that lasted half
a century, during which he described her as
someone who 'could make a pudding as well
as translate Epictetus from the Greek, and work
a handkerchief as well as compose a poem'.
One of the most learned Englishwomen of her day,
Carter was a noted linguist, who spoke several
European languages. She was also a classicist,
who knew Hebrew, Arabic, Latin and Greek, and
was especially celebrated, as Johnson acknowledges,
for her translation of the Greek stoic philosopher
Epictetus (*All the works of Epictetus, which are now
extant*, 1758). Otherwise, a poet, an engaging wit
and conversationalist, Carter established the first
generation of Bluestockings, alongside such
luminaries as Elizabeth Montagu, envisioning
a more expansive role for women in the world.
This portrait can be seen to celebrate her as
a role model for learned and creative women
everywhere, emphasising, as it does, her wisdom
(via her presentation in the plumed helmet and
armoured breastplate of Minerva, Goddess of
Wisdom) and her intellect (through the volume
of Plato in her hand, suggesting the area of her
learning).

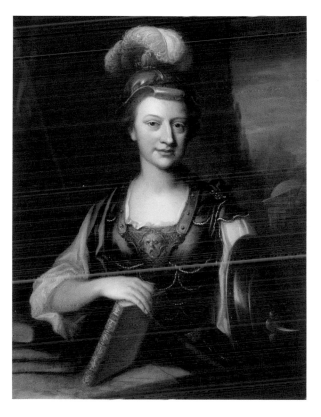

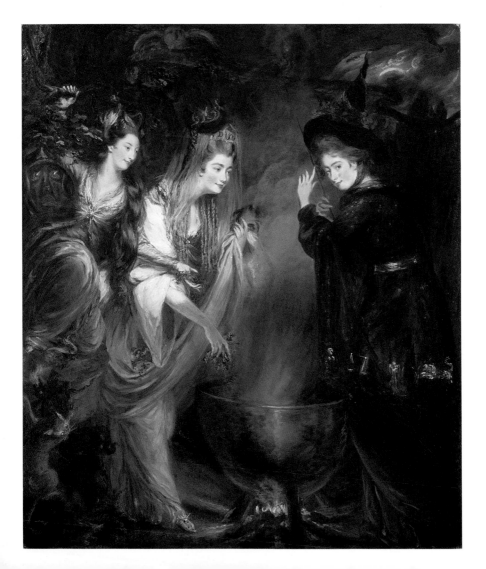

(Elizabeth Lamb, Viscountess Melbourne;
Georgiana, Duchess of Devonshire;
Anne Seymour Damer)
Daniel Gardner, 1775
Gouache and chalk, 940 x 790mm
• NPG 6903

Georgiana, Duchess of Devonshire (1757–1806),
first wife of the 5th Duke of Devonshire, was an
eighteenth-century aristocrat, fashion trendsetter
and social celebrity. Favoured by fortune, she
became the leading political hostess of her
time. Considered the unofficial 'queen of the
Whigs', she was the first woman to appear on
the political hustings. She might even be said
to have emboldened an early form of feminism,
participating in those areas of public life from
which women were customarily excluded. She
is depicted here with two friends: the political
hostess and agricultural improver Elizabeth
Lamb, Viscountess Melbourne, and Anne
Seymour Damer, a sculptor who inherited
Strawberry Hill from her cousin Horace Walpole.
This portrait reflects their status as three of the
most notorious women of their day, witch–sisters
in their passion for Whig politics and the arts.
The use here of the cauldron scene from *Macbeth*
– one of the most frequently painted scenes
from Shakespeare at that time – may relate to
their political string-pulling as leaders of the
Devonshire House circle, the then current craze
for Shakespeare and the Gothic, or simply to
their fondness for the theatre.

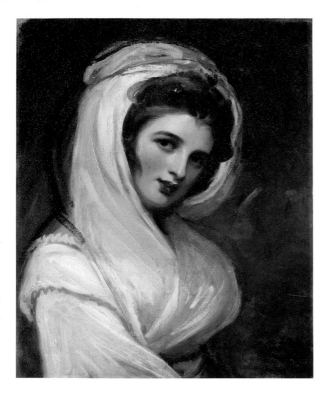

EMMA, LADY HAMILTON

George Romney, c.1785
Oil on canvas, 623 x 521mm • NPG 4448

Emma, Lady Hamilton (baptised 1765–1815),
is celebrated as Lord Nelson's mistress. She
was also muse to George Romney, who painted
her more than sixty times. From blacksmith
stock, she rose to riches in an era not known
for its social mobility. An irresistible beauty
and one-time dancer at the Georgian venue the
Temple of Health, she said (in 1791): 'I wish
… to show the world that a pretty woman is not
always a fool.' In 1791 she married Sir William
Hamilton, British envoy in Naples, where, two
years later, she met Horatio Nelson and found
enduring love and some some sense of equality
(since neither had been born wealthy, and both
were elevated by talent). Her 'Attitudes', a new
form of performance art based on the telling
of ancient myths in which she struck classical
poses using nothing but drapery and lighting
to evoke moods and moments from literature,
brought her international fame. She became a
confidante to the Queen of Naples and the first
woman awarded the Maltese Cross. In 1813,
after the deaths of Nelson and Hamilton, her
bankruptcy led to her arrest for debt (a pension
codicil to Nelson's will having been denied by
the government). She died, destitute, two years
later in Calais.

CATHARINE MACAULAY
Robert Edge Pine, c.1775
Oil on canvas, 1372 x 1048mm • NPG 5856

Described by Mary Wollstonecraft (1759–97) as a 'woman of the greatest ability, undoubtedly, this country has ever produced', Catherine Macaulay (1731–91) was a pioneering British historian and radical. A celebrated Bluestocking, she made her name through her eight-volume, political *History of England from the Accession of James I to That of the Brunswick Line* (1763–83), which was innovative in its broad-canvas approach to history-writing and strong in its Radical leanings. Her *Letters on Education* (1790), with its challenge to patriarchy, is said to have inspired Wollstonecraft's *Vindication of the Rights of Woman* (1792), while her political work, *Observations on the Reflections of The Right Hon. Edmund Burke on the Revolution in France* (1790), championed the Revolution. A republican sympathiser, she corresponded with George Washington, whom she had met in 1785, and who deemed her the spokesperson for radical England. Despite the restrictions on women at that time, she exerted influence, both politically and socially. A well-heeled widow from 1766, her second marriage in 1778 – to William Graham, a ship's mate, who was twenty-six years her junior – was proof of her lack of concern for social conventions or her critics. In this portrait, she is depicted wearing a sash of the kind worn by Roman senators (who were male), representing her commitment to republicanism and democracy.

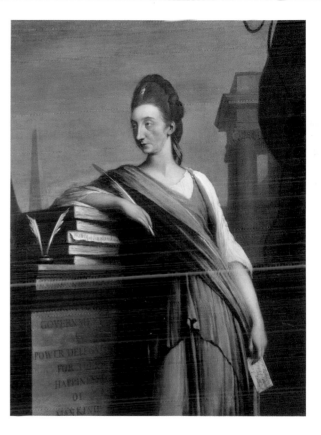

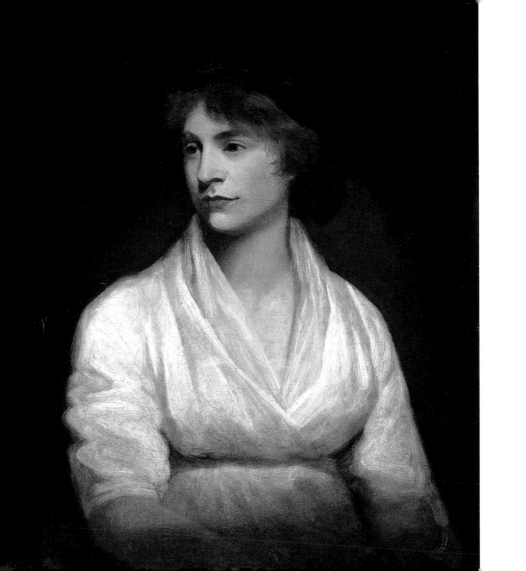

MARY WOLLSTONECRAFT
John Opie, c.*1797*
Oil on canvas, 768 x 641mm • NPG 1237

Mary Wollstonecraft (1759–97) was a journalist,
radical thinker, feminist and author, whom
Horace Walpole described as a 'hyena in
petticoats'. Her *Vindication of the Rights of Woman*
(1792) proposed an enlightened feminism and
equality between the sexes. She wrote: 'I do not
wish them [women] to have power over men;
but over themselves.' *Thoughts on the Education of
Daughters* (1787) revealed her as an educational
pioneer, too, believing (controversially) in
women's capacity to reason. During the French
Revolution she was in Paris, where she had her
first child, Fanny, out of wedlock. After returning
to England, she met and married in 1797 the
anarchist philosopher William Godwin, with
whom she had a second daughter, Mary – later
Mary Shelley, the author of *Frankenstein* (1818)
– dying days after her birth. After their marriage,
the couple had been the toast of radical circles
– but she was vilified, for her moral compass,
her politics and her ideas, by contemporary
critics and an increasingly conservative public.
Speaking in favour of a Wollstonecraft memorial
in Stoke Newington, the London area where
she lived and worked, Classics professor Mary
Beard said: 'Every woman who wants to make
an impact on the way this country is run … has
Mary Wollstonecraft to thank.'

SARAH SIDDONS WITH THE EMBLEMS OF TRAGEDY

Sir William Beechey, 1793
Oil on canvas, 2456 x 1537mm
• NPG 5159

The English actress Sarah Siddons (1755–1831), depicted here as the tragic muse, is a forerunner of modern thespians, such as Dames Judi Dench and Maggie Smith, pioneering, as she did, a more psychological approach to the craft. The eldest of actor–manager Roger Kemble's twelve children, she toured with his company throughout her childhood, marrying (in 1773) company member William Siddons. Her first appearance – as Portia in *The Merchant of Venice* at Drury Lane's Theatre Royal, under actor–manager David Garrick in 1775–6 – did not go well, despite her recognised ability to move an audience to tears. Her second, in the tragedy *Isabella* in 1782, was a sensation. It led to a sequence of other tragic roles and her acknowledgement as the peerless tragic actress of her day. Her portrayal of Lady Macbeth, in a production of 1812, was her swansong. A friend of Horace Walpole and Dr Johnson, and painted by Reynolds, Lawrence and Gainsborough, she became a respected celebrity, her portraiture securing her fame. Her funeral in 1831 drew more than 5,000 mourners.

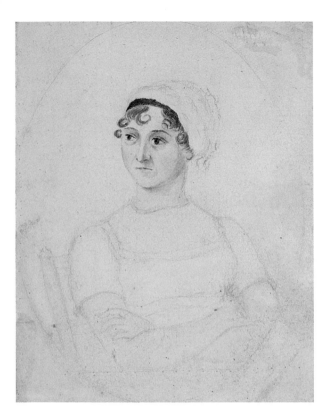

JANE AUSTEN

Cassandra Austen, c.1810
Pencil and watercolour, 114 x 80mm
• NPG 3630

An unknown country novelist and vicar's daughter, whose name first appeared on her novels after her death, Jane Austen (1775–1817) earned scarcely £650 from her books during her lifetime. But, two centuries on, her six great novels, from *Sense and Sensibility* (1811) to *Persuasion* (1817), have proved classic texts, required reading on English literature courses, reprinted and translated, retold and reinvented, for the big and small screen. Originally published anonymously, as 'A Lady', Austen is now famous worldwide as a pioneering fiction writer. Her early work satirised the social life and literature of her era. Virginia Woolf believed that if Austen had lived longer and written more, 'She would have been the forerunner of Henry James and of Proust.' In *Emma* (1815), some argue, she is. This likeness, sketched by her sister Cassandra, is thought to be the only portrait of the writer made from life.

MARY ROBINSON
George Dance, 1793
Pencil, 260 x 210mm • NPG 1254

The English actress and author Mary Robinson
(1756/1758–1800) became known as Perdita
after her success in that role in Shakespeare's
The Winter's Tale in 1779. Celebrated in her
youth as a great beauty, painted by the likes of
Reynolds and Gainsborough, she became the
mistress of the Prince Regent for four years,
after he saw her performance as Perdita. In
her early life, however, she had suffered great
hardship, finding herself, at sixteen, in debtors'
prison, having been bullied by her mother into a
disastrous marriage with the profligate Thomas
Robinson. It was on her release that actor–
manager David Garrick prepared her for her
debut at Theatre Royal, Drury Lane, London,
in 1776. Her subsequent stage success ended in
1780, however, with her role in Lady Craven's
The Miniature Picture, a poignant farewell. In her
mid-twenties, an unidentified illness left her
partially paralysed. Too enfeebled to return to
the stage, she began writing, prolifically, both
poetry and prose, both well regarded, and one
of her seven novels, *Vincenza* (1792), became a
bestseller. Her extensive literary circle included
Samuel Taylor Coleridge, Mary Wollstonecraft
and William Godwin, the latter describing her as
'a most accomplished and delightful woman, the
celebrated Mrs. Robinson'.

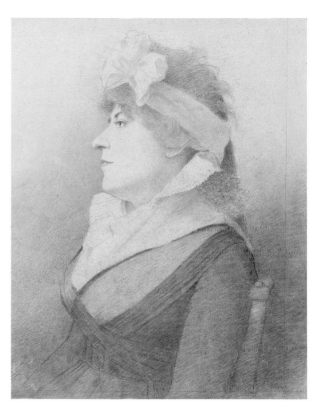

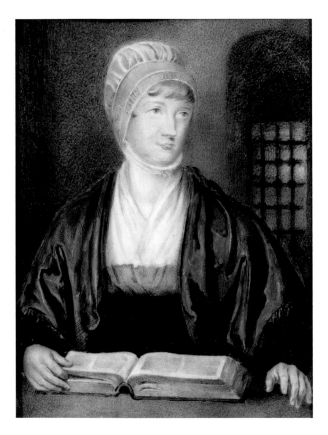

ELIZABETH FRY

Samuel Drummond, c.*1815*
Watercolour on ivory, 114 x 83mm • NPG 118

Elizabeth Fry (1780–1845) was a social reformer
and Quaker minister whose work led to dramatic
improvements in prison conditions, and many of
whose ideas resulted in changes to legislation.
She was inspired to become an activist for prison
reform after visiting London's Newgate prison
in 1813 and witnessing the dire living conditions
of the female inmates and their children there.
At a time when women rarely led such campaigns,
she was the first of her sex to fight for penal
reform, highlighting prisoners' humanitarian
needs and prison's rehabilitative potential
over society's demand for punishment and
retribution. In 1818 she was the first woman to
present evidence in Parliament, to a committee
on British prison conditions, having helped to
form the Association for the Improvement of the
Female Prisoners in Newgate the previous year.
In 1821, Fry formed the British Ladies Society
for the Reformation of Female Prisoners, one
of Britain's first women's organisations. She would
also establish homeless hostels and charitable
societies, founding the Institute of Nursing
Sisters in London, a training school for nurses,
in 1840. Florence Nightingale took a team of Fry's
nurses to the Crimea. This miniature shows
Fry giving a Bible reading to prisoners.

MARY ENGLISH
William Hobday, 1818
Oil on canvas, 760 x 630mm • NPG 6964

The daughter of a Kentish dockworker, Mary English (1789–1846) was an adventurer and businesswoman. She first travelled to South America with her second husband, General James Towers English, who was fulfilling a contract with Simon Bolívar's government to recruit and equip a British force of 1,000 men. Six months after reaching Venezuela, having arrived in April 1819, James died. Mary stayed on, as the representative of the bankers Barclay, Herring, Richardson & Co. As a politicised acquaintance of Bolívar's, Mary was soon at the heart of Bogotá's social scene. Highly sought after, her third marriage, in 1827, was to the trader William Greenup, with whom she bought a rural estate in Cúcuta, producing cacao for export. In a letter of 1829, written after William returned to England for ten years, she remarks: 'I am now quite alone … To me this is indifferent as I am not fearful.' Her letters home, intended for publication in the periodical press, portray her extraordinary life and character. Her papers include a poem in Bolívar's hand, a signed letter from Bolívar and lock of his hair. In this portrait she is depicted wearing a female version of romantic 'byronic' costume, with an orientalising turban and Kashmiri shawl.

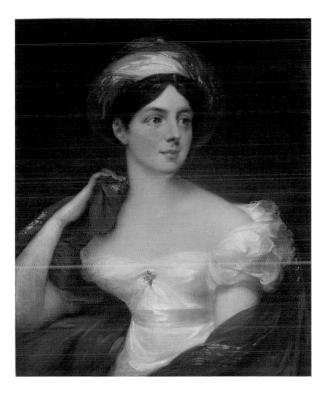

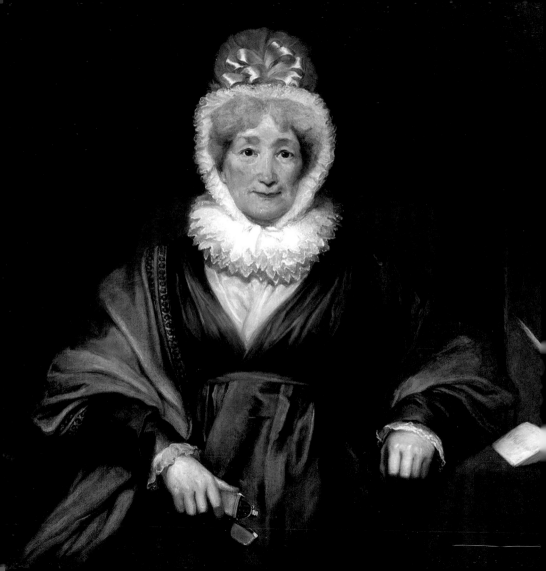

HANNAH MORE
Henry William Pickersgill, 1822
Oil on canvas, 1257 x 895mm • NPG 412

The influential dramatist, religious writer and
Evangelical social reformer Hannah More
(1745–1833) was born a schoolteacher's daughter,
near Bristol. Both a successful promoter of
female activism and a conservative feminist, she
was a prolific author; her first published play
was *The Search for Happiness* (1773). On moving
to London in 1774, she joined the Bluestocking
circle, after which she wrote two more plays,
Percy (1777) and *The Fatal Secret* (1779), for
actor–manager David Garrick. Following her
retreat from London society, for reasons of faith,
she continued to write. Her campaigning moral
tales *Village Politics* (1792), written under the
pseudonym 'Will Chip', and *Cheap Repository
Tracts* (1795–8), inexpensively produced,
populist and anti-radical, sold more than two
million copies in less than two years. Many
were circulated by the middle classes in their
communities in the hope that their homilies
would encourage an awareness of poverty and
the need for charitable work among the poor.
In the wake of its success, the Religious Tract
Society was founded in 1799. Educated at a
school run by her sisters, More expressed her
reforming zeal for women's education in *Strictures
on the Modern System of Female Education* (1799).

MARY SOMERVILLE
Sir Francis Leggatt Chantrey, 1832
Pencil, 486 x 651mm • NPG 316a(114/115)

Mary Somerville (1780–1872) was a Scottish mathematician and scientist, and a proponent of the emancipation and education of women. Born in Jedburgh, to Admiral Sir William Fairfax, an early chance encounter with algebra stirred her curiosity, which, with a will to learn and a move to London in 1816, drew her into intellectual and scientific circles. Although she was a highly intelligent woman, her grasp of advanced mathematics was not always appreciated in a world that expected little of her gender. Her glittering career in the male-dominated world of science and mathematics was consolidated by the success of *The Mechanism of the Heavens* (1831), then *The Connection of the Physical Sciences* (1834). In a preface to the latter, she expressed her wish 'to make the laws by which the material world is governed, more familiar to my country-women'. Somerville Hall, Oxford, named in honour of her, was founded in 1879. Its founders identified her as 'a public intellectual in an age against women pursuing academic careers', thereby declaring their ambition for their women students. Somerville is seen here in preparatory sketches for a marble bust in the Royal Society.

ADA KING, COUNTESS OF LOVELACE

William Henry Mote, after
Alfred Edward Chalon, published 1839
Stipple engraving, 315 x 227mm
• NPG D5124

Augusta Ada King (1815–52), Countess of Lovelace, was a computer pioneer, writer and mathematician, dubbed 'enchantress of numbers' and 'prophet of the computer age' by one biographer. Encouraged by her mother, Lady Byron, Ada fought for her right to an education, teaching herself geometry and training in astronomy and mathematics. Charles Dickens and Michael Faraday were among the Victorian luminaries of her acquaintance, as was the English mathematician, inventor and computer pioneer Charles Babbage. Her notes on her translation of a paper by an Italian mathematician, which explain how Babbage's analytical engine (the 'mechanical computer') might be programmed, have led to her being credited as the first computer programmer. She was certainly integral to the birth of the computer revolution. ADA, the universal computer-programming language developed in the 1980s, is named in tribute to her. The Romantic poet Lord Byron's only legitimate daughter, it is said there are more pilgrimages to her grave than to that of her father.

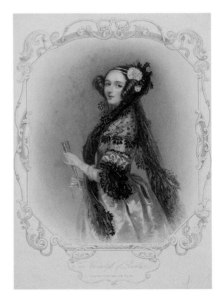

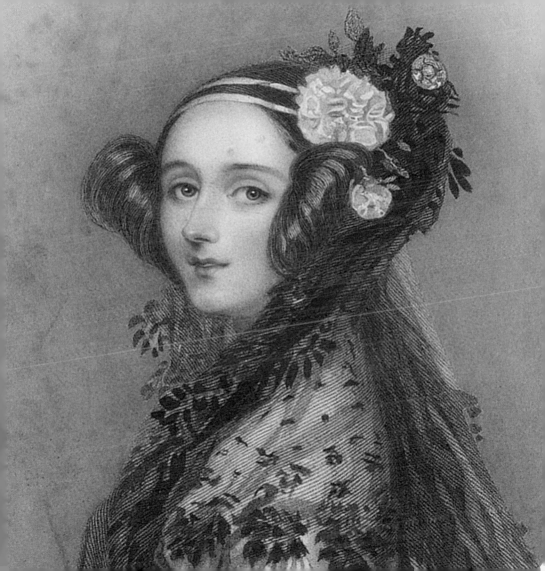

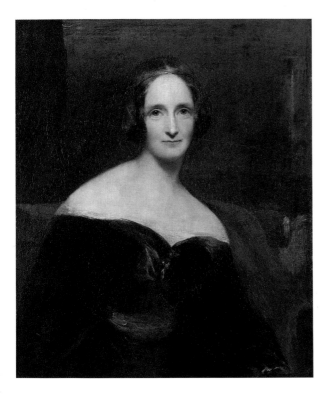

MARY WOLLSTONECRAFT SHELLEY

Richard Rothwell, exhibited 1840
Oil on canvas, 737 x 610mm • NPG 1235

Writer and novelist Mary Wollstonecraft Shelley (1797–1851) is the author of the Gothic masterpiece *Frankenstein* (1818), one of the most important books in the history of literature, an enduring cultural milestone and, arguably, the first work of science fiction. Born to radical freethinkers Mary Wollstonecraft and William Godwin, she married the poet and political activist Percy Bysshe Shelley in 1816, following their elopement, behaviour that saw her shunned by society. Yet she remained a free and determined spirit, a woman of diverse talents, whose life was defined by death and desertion (including her mother's death from septicaemia days after her birth, the early demise of three of her four children and her unfaithful husband's untimely end when she was twenty-five). Her second novel, *Valperga* (1823), was published the year after Percy Shelley's death by drowning, and thereon, as his editor, she established his posthumous reputation. She herself wrote prolifically, not just novels (including her acclaimed futuristic work, *The Last Man* (1826), perhaps the earliest English novel to deal with post-apocalyptic themes) but also innovative short stories and plays, and journals and essays. Her travel books frame her literary career, from *History of a Six Weeks' Tour* (1817) to *Rambles in Germany and Italy* (1844), an inspiringly creative oeuvre, despite a challenging life.

JULIA MARGARET CAMERON

George Frederic Watts, 1850–2
Oil on canvas, 610 x 508mm • NPG 5046

The British photographer Julia Margaret Cameron
(1815–79) developed a passion for the art of
photography at a time when it was especially
arduous and challenging. She was forty-eight
when her daughter and son-in-law gave her
a camera, with which she immediately became
enthused, even taking the trouble to turn her
coal-house into a dark room. Using standard
bulky equipment and hazardous materials,
Cameron would become an audacious and
pioneering image-maker. Her innovative
compositions favour the portrayal of emotion
over technical precision. She deemed her portrait
of Annie Philpot of 1864 her first triumph,
and her imposing close-ups of Thomas Carlyle
and Sir William Herschel (both taken in 1867),
among other Victorian notables, would draw
public attention. But her sitters also included
the less famous - family, friends and servants –
styled allegorically or in historical or Biblical
tableaux. In a letter to Henry Cole, the founding
director of London's Victoria & Albert Museum,
she wished, she said, to 'electrify you with delight
and startle the world'. In that she succeeded.

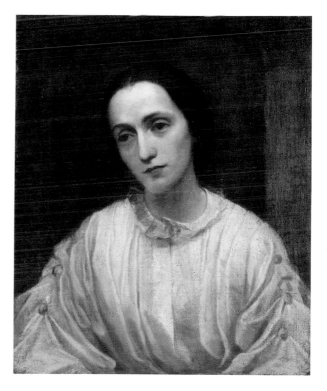

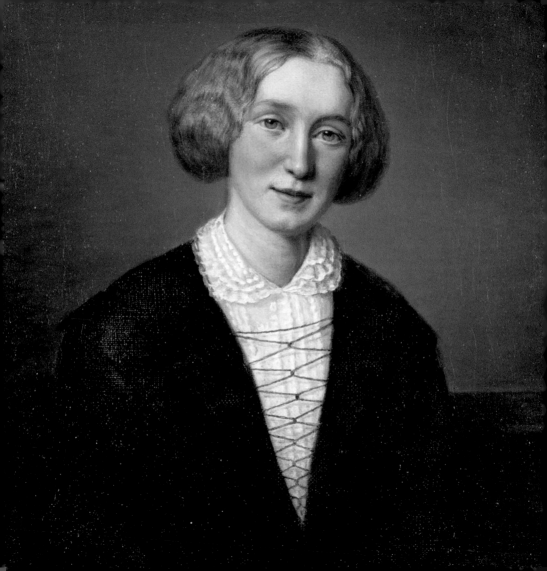

GEORGE ELIOT

Replica by François D'Albert Durade, 1849–86, based on a work of 1849

Oil on canvas, 343 x 267mm • NPG 1405

The novelist George Eliot (pseudonym of Mary Ann Cross, 1819–80) is one of the greats of nineteenth-century English literature. She wrote of herself: 'I have turned out to be an artist – with words.' The author of many acclaimed works, starting with *Adam Bede* (1859), her masterpiece is *Middlemarch* (1871–2), subtitled *A Study of Provincial Life*. Her novels are mostly about rural provincial life and feature weavers, millers' daughters and carpenters (of which her father was one). An intellectual and a famed literary stylist, thinker and observer, she earned her living from a career in writing that began at the *Westminster Review*. Her literary circle included the philosopher and critic G.H. Lewes, with whom she lived until his death in 1878, after which she married John Cross. In her own name she worked as an editor and critic, and although she published her novels under a male pseudonym, she nonetheless challenged the masculine bias of her world. She did things her way, regardless of the opprobrium this attracted, especially of her personal life.

FLORENCE NIGHTINGALE

William Edward Kilburn, c.1856
Albumen carte-de-visite, 89 x 56mm
(image size) • NPG x16135

The pioneering nurse, social and healthcare
reformer Florence Nightingale (1820–1910)
turned her back on a genteel English upbringing
and on marriage as a woman's vocation. Training
instead as a nurse in Kaiserswerth and Paris,
in 1853 she became superintendent of a London
hospital for women. The following year, at
the Scutari Barracks army field hospital in
the Crimea, she reversed the insanitary and
overcrowded conditions, thereby setting the
standards for modern nursing. She introduced
a system of medical records, facilitated by her
study of maths as a child (her parents endorsing
women's education), led to her election as the
first female member of the Royal Statistical
Society, in 1858. After returning from Crimea,
she called for women nurses in military
hospitals, and in 1860 founded the Nightingale
Home and Training School for Nurses, one of
the first to teach nursing and midwifery as a
formal profession. She also helped introduce
professional nursing to workhouse infirmaries
and envisioned a public healthcare system within
a wider context of social welfare.

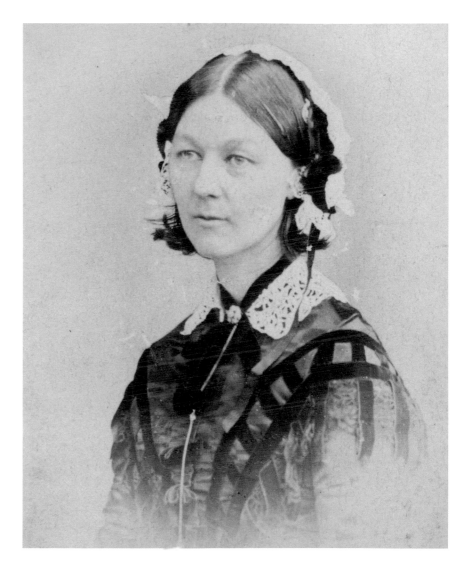

BARBARA BODICHON

'Holmes of New York', 1857/8
Ambrotype, 83 x 64mm • NPG P137

As leader of England's feminist organisation, the Langham Place Group, the artist and activist Barbara Leigh Smith Bodichon (1827–91) was central to the Rights for Women movement in the late nineteenth century. She also co-founded the Kensington Society, a suffragist discussion group that would eventually expand into the National Society for Women's Suffrage. Bodichon trained as a painter at Bedford Ladies' College, London, and in Paris, with the prominent French artists Jean-Baptiste-Camille Corot and Charles-Francois Daubigny of the Barbizon school, and her artistic circle included the Pre-Raphaelites Dante Gabriel Rossetti and Elizabeth Siddal. Bodichon exhibited widely between 1850 and 1881, and landscapes inspired by her travel in North Africa proved particularly successful. Having been brought up in a politically radical family, Bodichon's early activism was closely linked to her professional ambition; she campaigned to raise the status of women artists through the foundation of the Society for Female Artists in 1857. Later, she was active in promoting women's wider educational opportunities and co-founded Girton College, Cambridge, with Emily Davies in 1869. Bodichon's most influential political tract was 'Reasons for the Enfranchisment of Women' (1866), in which she declared: 'under a representative government, any class which is not represented is likely to be neglected'. Having achieved her own ambition, she fought lifelong for other women to be able to so, too.

ISABELLA BEETON
Maull & Polyblank, 1857
Hand-tinted albumen print, 184 x 149mm
• NPG P3

Isabella Beeton (1836–5; popularly known as 'Mrs Beeton') was a journalist and editor. Her *Book of Household Management* was first serialised in 1859 and 1860 in the *Englishwoman's Domestic Magazine* (*EDM*) – a venture launched in 1856 by her husband, the enterprising publisher Samuel Orchard Beeton. Published as a book in 1861, it became a phenomenon, selling some two million copies by 1868, and has remained in print ever since. As well as recipes, it features helpful hints on household management, from etiquette and childcare to entertaining. Extensively illustrated with colour engravings, its innovative formatting was ahead of its time. Beeton was a working journalist in an era when the contribution of women was considered to undermine journalism's professional status. From 1856 to 1865 she was, with Samuel, joint editor of *EDM*, a cheap, popular monthly for young middle-class women, writing on home management, embroidery, dressmaking and cookery, and translating the serialised French novels that it featured. Her early death from a post-partum infection that set in following the birth of her fourth child cut short an inspiring life. This portrait of Beeton was one of the first photographs to enter the Collection of the National Portrait Gallery.

ber 15th

11697

Mrs G P L Davies

SARAH FORBES BONETTA

Camille Silvy, 1862

Albumen print, 83 x 56mm (image size)

• NPG Ax61380

Sarah Forbes Bonetta (later Davies, 1843–80), Queen Victoria's goddaughter, was a West African Egbado princess of the Yoruba people. Caught up in intertribal warfare, in which she saw her family slaughtered, she was captured in 1848 by Dahomey raiders, then traded, as a present, to Queen Victoria, 'from the King of the Blacks to the Queen of the Whites'. Her Yoruba name was Aina, but her captors named her Sarah Forbes, after the British emissary who negotiated her transfer, and Bonetta, after his ship, she was described by Captain Forbes in his journal as possessing 'intelligence of no common order'. She was brought up under Victoria's protection. The Queen, impressed by her many qualities, funded her education and encouraged her visits. In Brighton in 1862, she married James Pinson Labulo Davies, a wealthy Yoruban, in a lavish ceremony, returning to West Africa, where she settled in Lagos. (This photograph is one of several that were taken by the London-based portrait photographer Camille Silvy to mark the wedding, pasted into one of the daybooks that record his work.) Sarah's first child, Victoria, was also a godchild of the Queen. In her life, cut short by tuberculosis, she summoned strength and dignity in difficult times.

QUEEN VICTORIA
Replica by Sir George Hayter, 1863,
based on a work of 1838
Oil on canvas, 2858 x 1790mm • NPG 1250

On the throne from 1837 until her death, Queen Victoria (1819–1901) was the United Kingdom's longest-reigning monarch until her great-great-granddaughter Elizabeth II surpassed her in 2015. On her accession, aged eighteen, she described herself as 'full of courage'. Her Empire covered a quarter of the globe and 400 million subjects. She was known for her iron will – evident in her response when offered commiseration on British reverses in the Boer War (1899–1902): 'We are not interested in the possibilities of defeat; they do not exist.' She reinvigorated Britain's monarchy, reconnecting it with the people through civic duty – she was patron of some 150 institutions. In 1840, she married Prince Albert, her cousin. They had nine children, whom Victoria helped marry into European royalty. She transformed herself into the figurehead of the world's most powerful nation, though one undergoing great change.

MARY SEACOLE

Albert Charles Challen, 1869
Oil on panel, 240 x 180mm • NPG 6856

Mary Jane Seacole (1805–81) was a pioneering
nurse, adventurer and writer. Born in Jamaica,
she is celebrated for her heroic nursing
endeavours in the Crimea. As a woman of mixed
race, she laboured under a double prejudice,
but her reputation came to rival that of Florence
Nightingale. Despite nursing experience,
gained at a home for invalids that was run by
her mother, and her extensive travels, the War
Office refused her request to go to the Crimea
as an army nurse. Instead she got there herself,
helping establish the British Hotel in Balaclava
as 'a mess-table and comfortable quarters for
sick and convalescent officers'. Her efforts on
the battlefield, embattled and nursing the sick,
led to her name 'Mother Seacole'. By the time
she returned to England in 1856, penniless and
in poor health, her fame had spread through
William Howard Russell's letters to *The Times*
about the Crimea, highlighting the suffering
and parlous army conditions there, and praising
Seacole's 'errand of mercy'. The following year,
a Seacole benefit festival attracted thousands, and
she published her memoir, *Wonderful Adventures
of Mrs Seacole in Many Lands*.

DAME ELLEN TERRY
George Frederic Watts, c.1864–5
Oil on canvas, 612 x 608mm • NPG 2274

Ellen Alice Terry (1847–1928) was the foremost
English actress of her generation, known
especially for her theatrical association (between
1878 and 1902) with the actor–manager Henry
Irving and celebrated in both Britain and
America. Born to actor parents, her first stage
appearance, at the age of nine, was in Charles
Kean's 1856 production of *The Winter's Tale* at
the Princess's Theatre. She remained with Kean
until 1859, before moving to Bristol's Theatre
Royal. In 1864, she left the stage to marry
painter and sculptor G.F. Watts, for whom she
had modelled, but they soon separated (she
would marry again twice), and a mutual friend
commented that Watts 'might as well marry the
dawn or the twilight or any other evanescent
and elusive loveliness of nature'. After a brief
return to the stage, she left again to live with the
architect and theatrical designer Edward Godwin
and have two children. Returning to acting in
1874, her Portia in *The Merchant of Venice* (1875)
showcased her renewed vigour and maturity.
But it was as Irving's leading lady that she
excelled, touring nationally and internationally,
celebrated for her many Shakespearean roles.
In 1899, the leading society artist John Singer
Sargent painted her in the role of Lady Macbeth
in what has become one of his most famous
portraits. In 1906, for her golden jubilee at the
Theatre Royal, Drury Lane, she celebrated with
a host of theatrical luminaries. She remained in
the limelight for the rest of her life, as a theatre
manager and producer, actress, writer and
lecturer, and, in 1925, a Dame.

ELIZABETH SOUTHERDEN, LADY BUTLER

Self-portrait, 1869
Oil with traces of pencil on card,
219 x 181mm • NPG 5314

Elizabeth Southerden (1846–1933) was an
acclaimed military artist and history painter.
Her first major work, *Calling the Roll After an
Engagement, Crimea* (1874), attracted huge
crowds at London's Royal Academy of the Arts'
Summer Exhibition. Such was the work's appeal
that Queen Victoria, who purchased it, agreed
to prints being taken. The Pre-Raphaelite
William Holman Hunt commented on how it
'touched the nation's hearts as few pictures have
ever done'. This was partly due to the artist's
departure from the conventional depiction
of vast battle panoramas, which glorified war,
portraying, instead, the struggles and suffering
of the soldiers, and thereby heralding a realism
that chimed with the public. But the artist
herself – gifted, young and female – also caused
a stir. The male-dominated art establishment
was not ready for her, when, in 1879, she was
proposed but not elected to the Royal Academy.
Nonetheless, she paved the way for later women
Royal Academicians, notably Dame Laura
Knight, who would be elected in 1936.

FRANCES MARY BUSS

James Russell & Sons, c.1875
Albumen print cabinet card,
146 x 105mm • NPG P719

Frances Buss (1827–94), campaigner for women's rights and pioneer of education for women, was the founder, then (from 1850 to 1894) head of the North London Collegiate School for Ladies: the first girls' school targeted at university entrance. She was part of the Kensington Society (formed in 1865), a prime goal of which was increased educational opportunities for women. The first woman to call herself 'headmistress', along with Dorothea Beale of Cheltenham Ladies' College, she was undermined in rhyme, as a spinsterly type, with a career but no love life: 'Miss Buss and Miss Beale / Cupid's darts do not feel'. The derogatory nature of the verse is evidence of the hostile opposition to her ambitions for young women at the time, when even the medical profession produced 'proof' of the damaging effect of education on girls. Buss ploughed on, regardless, her beliefs consolidated in the Camden School for Girls, the second girls' school she founded, in 1871. Hers was a radical vision of educated girls, at a time when those two words were deemed not to sit well together.

LOUISE JOPLING

Sir John Everett Millais, 1st Bt, 1879
Oil on canvas, 1240 x 765mm • NPG 6612

Louise Jane Jopling (1843–1933), portrait–genre painter, teacher and suffragist, was prominent in an era when women in the arts were often dismissed with the label 'amateurism'. In 1887, she established a painting school for women (where her friend James McNeill Whistler distributed prizes). She also published a book of art instruction. Her essay 'On the Education of the Artistic Faculty' (1903) supported women's education on equal terms with men. A member of the National Union of Women's Suffrage, she pushed for women to be allowed to work from nude models (not required to sketch strategically draped men). One of the first women admitted to the Royal Society of British Artists (in 1901), she exhibited alongside men. Nonetheless, she felt frustrated at the limitations of being a woman in a man's world, saying: 'I hate being a woman … Women never do anything', feelings she expanded on further in her forthright memoir, *Twenty Years of My Life: 1867–87*.

HENRIETTA WARD

(William) Walker Hodgson, 1891

Black chalk on wove paper, 300 x 225mm

• NPG 7037

Henrietta Mary Ada Ward (1832–1924) was a British artist with a successful career as an historical genre painter. Part of an artistic family – her father, grandfather and husband were all artists – and living at a time when the number of prominent women artists was small but growing, she first exhibited a drawing at London's Royal Academy of Arts (RA) in 1846, and exhibited there annually until 1904. In the 1850s, she taught Queen Victoria's children and enjoyed royal commissions. Her historical genre painting generally depicted the female heroism of women, of towering figures such as Joan of Arc or Mary Queen of Scots, in scenes often featuring children. She exhibited nationally, including at the 1851 Great Exhibition, and internationally. Nonetheless, painting, although acceptable as a hobby, remained rare as a woman's career. Despite her success, she and other women artists faced discrimination, evident in her failure to be elected (in 1875 and 1876) to the RA, when full eligibility to join such organisations was still restricted to men. In 1889, she signed a Declaration in Favour of Women's Suffrage.

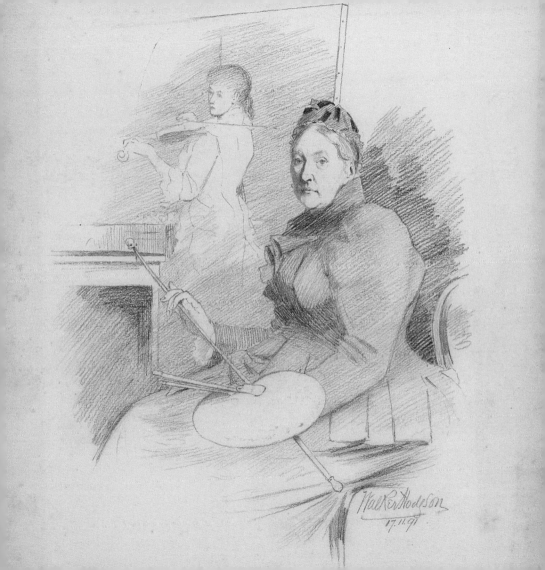

Walker Hodgson
17.11.91.

LOTTIE DOD

*W. & D. Downey, published by
Cassell & Company, Ltd, 1892*
Carbon print, 140 x 95mm
• NPG Ax16009

According to *Guinness World Records*, Lottie Dod
(1871–1960) was the 'most versatile female
athlete of all time'. In 1887, at her first attempt,
she won the Wimbledon Ladies' Singles
Championship, a success she would repeat four
times. Unlike some female contemporaries,
Dod preferred the forehand drive, and she
became the first woman to volley and smash.
Her achievements on the tennis court were topped
with extraordinary sporting prowess elsewhere.
She excelled at mountaineering, scaling two
mountains above 4,000 metres in 1896. She was
the first woman to complete the St Moritz Cresta
Run and passed the Ladies' and Men's Skating
Test, both top figure-skating events. In field
hockey, she captained Cheshire County Team,
gaining caps (in 1899 and 1900) for England.
In 1904, she won the British Ladies' Amateur Golf
Championships, and in 1908 a silver medal in
archery at the London Olympics. Sports aside,
she sang (contralto) and played both piano and
banjo. After serving as a nurse in the First World
War, she was awarded a Red Cross gold medal.
Less 'The Little Wonder', as she was known,
more a great one.

MARY 'MAY' MORRIS
Frederick Hollyer, c.1886
Platinotype cabinet card, 147 x 103mm
• NPG x19858

Mary 'May' Morris (1862–1938), designer
and craftswoman, was integral to the Arts and
Crafts movement. The younger daughter of the
designer, author and socialist visionary William
Morris, she was brought up amid his circle, which
included the Pre-Raphaelites (she posed for
Rossetti) and George Bernard Shaw (with whom
she had a tumultuous affair). She married Henry
Halliday Sparling, Secretary of the Socialist
League, in 1890. She elevated embroidery to
the status of an 'art', having first partly learnt it
from her mother, Jane, and studied embroidery
and textiles at the National Art Training School,
London. In 1885, she joined the embroidery
branch of her father's firm, Morris & Co., which
she managed, designing textiles, jewellery
and wallpaper in the Morris house style. After
leaving Morris & Co. in 1896, her passion for
craft and embroidery continued unabated. She
taught at London's Central School of Arts and
Crafts, co-founded (in 1907) the Women's Guild
of Arts, and wrote and undertook US lecture
tours. Rekindling her friendship with Shaw, she
abandoned her habitual modesty, writing to him:
'I'm a remarkable woman – always was, though
none of you seemed to think so'

ELIZABETH GARRETT ANDERSON

John Singer Sargent, 1900
Oil on canvas, 838 x 600mm
• NPG L254

A member of the Kensington Society (formed in 1865), a forum for women's suffrage and education, Elizabeth Garrett Anderson (1836–1917) was the first woman to qualify in Britain as a physician and surgeon. Inspired by Elizabeth Blackwell, North America's first woman physician, she gained her medical qualifications as the result of a loophole in the Society of Apothecaries' entry requirements, which did not bar women, specifically, from their exams. After she passed (in 1865), the Society's rules were amended to exclude women. Determined then to further her medical credentials, she learnt French in order to attend university in Paris, where she gained an MD (a qualification not recognised by the British Medical Register). In 1872, she founded London's New Hospital for Women, which was staffed by women (later renamed after her), and where Elizabeth Blackwell was professor of gynaecology. Her ambition, for herself and others, was acknowledged in a parliamentary act of 1876 that allowed women to enter the medical profession. In 1908, she became England's first woman mayor – of the Suffolk coastal town of Aldeburgh, her childhood home.

OCTAVIA HILL
John Singer Sargent, 1898
Oil on canvas, 1020 x 822mm
• NPG 1746

Octavia Hill (1838–1912) was a housing and social reformer, devoted to the promotion and provision of affordable housing. She understood the potential for women to enhance the lives of the poor, identifying her vocation in social housing. Hill's art tutor, the aesthete, critic and reformer John Ruskin, helped launch her ambition, purchasing London slum properties for her to manage. Her plan was to make 'lives noble, homes happy and family life good'. Henceforth, with ever more dwellings, she transformed slums and created thriving communities. Her methodical approach and use of trained volunteers paved the way to professional housing management. Hill's magazine articles, collected as *Homes for the London Poor* (1875), highlighted her work and methods, which spread internationally. A leader of the open-space movement, her other charitable activities included co-founding both the Charity Organisation Society in 1869 and the National Trust for Places of Historic Interest and Natural Beauty in 1895.

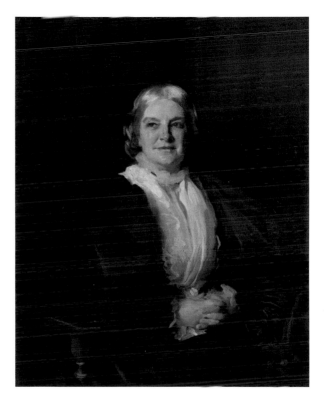

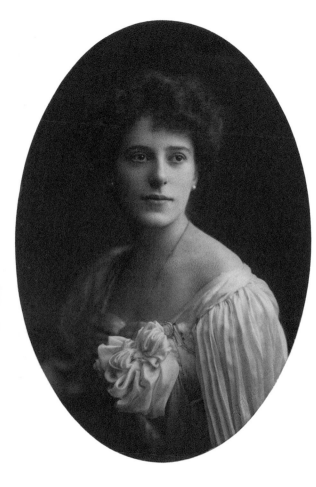

RACHEL BEER
H. Walter Barnett, 1900–3
Platinum print, 150 x 100mm
• NPG x68859

Born in India, into a wealthy Jewish family that
moved to the UK while she was still a baby,
Rachel Beer (1858–1927) was the 'first lady of
Fleet Street': the first woman to edit and own
a national broadsheet newspaper. In an era in
which women's lives were highly circumscribed,
she lived hers undaunted, exhibiting tremendous
spirit and determination. A rich heiress and
Mayfair socialite, she volunteered as a hospital
nurse before marrying, in 1887, Frederick Arthur
Beer, proprietor of the *Observer* newspaper,
of which she became the editor in 1891. Two
years later, she purchased its chief competitor,
the *Sunday Times*, which she edited between
1893 and 1904, thereby becoming the only
woman editor, ever, of two rival Sunday
newspapers. At the *Observer*, she was behind
the journalistic scoop of the Dreyfus Affair, a
political scandal that rocked France in the 1890s.
She was also a composer who published a piano
sonata and trio. The poet Siegfried Sassoon was
her nephew.

VESTA TILLEY

Published by The Philco Publishing Co., 1900s
Gelatin silver print, 136 x 86mm
• NPG Ax160040

Vesta Tilley (the stage name of Matilda Alice Powles, 1864–1952) was a music-hall entertainer and male impersonator who 'felt that [she] could express [her]self better if [she] were dressed as a boy' and first wore male attire on stage aged five. In 1874, she debuted her solo songs-and-impressions routine on the London stage at Canterbury music hall and was later rated Britain's most successful male impersonator. Her fop and dandy impersonations, performed in immaculate male dress (including undergarments), transformed her into a male fashion icon. Burlington Bertie, the man-about-town of her eponymous, smash-hit song, was her most beloved character. Hugely popular, she was adored by women, especially, who perhaps enjoyed her send-up of male foibles – but maybe, too, because of her inspiring financial independence (her weekly earnings were said to have been £500). During the First World War, her songs (such as 'Jolly Good Luck to the Girl Who Loves a Soldier') and her persuasive performances so encouraged enlistment that she was dubbed 'England's greatest recruiting sergeant'. On the knighthood of her husband, Walter de Frece, she became Lady de Frece.

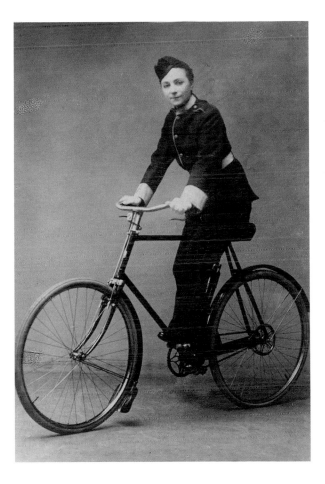

VIRGINIA WOOLF
Vanessa Bell (née Stephen), 1912
Oil on board, 400 x 340mm • NPG 5933

Virginia Woolf (née Stephen, 1882–1941),
novelist and critic, was a founding member of
the free-thinking Bloomsbury Group of writers,
artists and intellectuals, who, as Dorothy Parker
remarked, 'lived in squares, painted in circles
and loved in triangles'. From 1905, with her
sister, artist Vanessa Stephen (later Bell), she
hosted gatherings in Bloomsbury, London.
This portrait of her knitting is by Vanessa,
painted shortly before her marriage to writer
and publisher Leonard Woolf and at the time
she was at work on her first novel, *Melymbrosia*,
published as *The Voyage Out* (1915). Despite her
struggles with mental illness, Woolf became a
prolific author and pioneer of the novel form
in twentieth-century English literature. In her
innovative use of 'stream-of-consciousness'
and the internal monologue – notably, in *Mrs
Dalloway* (1925), *To the Lighthouse* (1927) and
The Waves (1931) – she breached conventions of
structure, plot and characterisation. She pushed
at boundaries elsewhere, too: in *A Room of One's
Own* (1929), now a classic feminist tract, she
criticised sexual inequality, especially women
writers' intellectual subjugation.

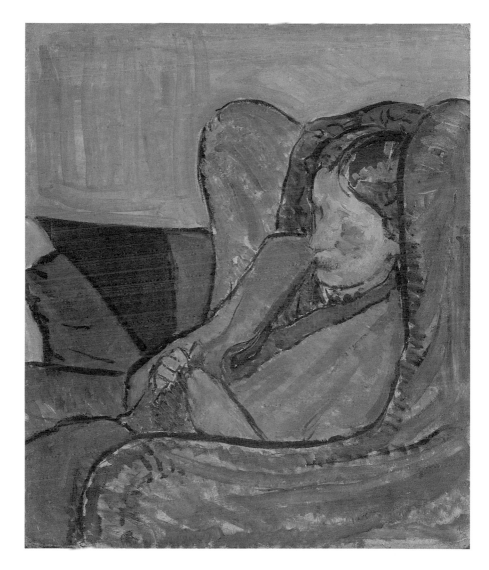

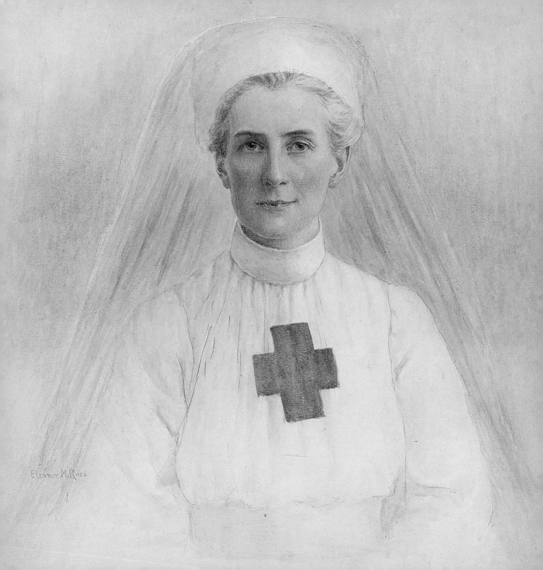

EDITH CAVELL

Eleanor M. Ross, c.1917
Watercolour and pencil, 511 x 371mm
• NPG 5322

Edith Louisa Cavell (1865–1915) was a war hero
and pioneering nurse, who saved lives on both
sides of the conflict during the First World War.
From a religious background, she worked first as
a governess (in Essex and Brussels) then trained,
in 1896, as a nurse at the Royal London Hospital.
For her work during a typhoid outbreak of 1897,
she earned the Maidstone Medal. In 1907, after
nursing in London and Manchester, she returned
to Brussels, as the first matron of Berkendael
Medical Institute. Motivated by the work of the
innovative Belgian physician Dr Antoine Depage,
she was charged with training nurses in medical
care (since the nuns who traditionally cared for
the sick were not medically trained). During the
war, the Red Cross conscripted Berkendael
for anyone in medical need. Sympathetic to
the Resistance, Cavell hid Allied soldiers there,
aiding their escape – and for this, she was
executed. Cavell wished to be known as a nurse
who did her duty; her biographer Diana Souhami
begs to differ: 'If she isn't a saint, who is?' Her
memorial, by the sculptor Sir George Frampton,
is in St Martin's Place, London, opposite the
entrance to the National Portrait Gallery.

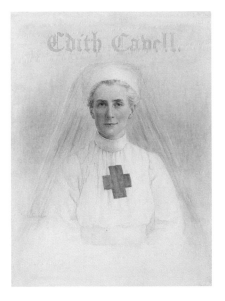

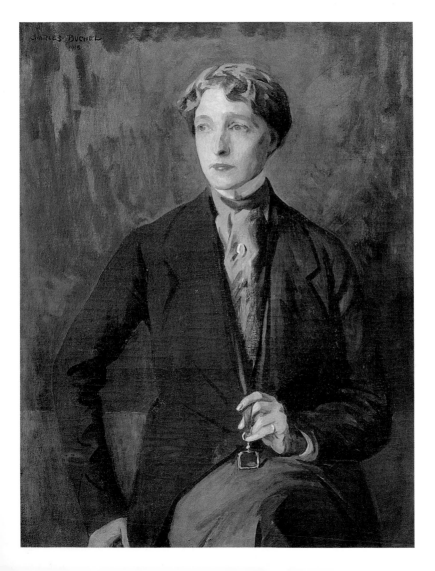

RADCLYFFE HALL

Charles Buchel (Karl August Büchel), 1918
Oil on canvas, 914 x 711mm • NPG 4347

The writer and poet Radclyffe Hall (née
Marguerite Antonia Radclyffe-Hall, 1880–1943)
is best known today for her semi-autobiographical
novel *The Well of Loneliness*, which invoked public
outrage following its publication in 1928, for its
candid and sympathetic depiction of a lesbian
relationship. Despite protestations from Vera
Brittain, Arnold Bennett, T.S. Eliot and other
eminent contemporaries, the publication was
banned in Britain. In a letter of thanks to one
supporter, following the furore, Hall explained.
'I wrote the book in order to help a very much
misunderstood ... section of society.' A woman
of independent means, Hall had first published
several volumes of verse under her full name,
before turning to novels from 1924. *Adam's Breed*
(1926) was awarded two prestigious literary
awards, the James Tait Black Memorial Prize
(1926) and Prix Femina Vie Heureuse (1927).
The ban on *The Well of Loneliness* was overturned
in 1949, six years after Hall's death. Her life, like
her writing, was ground-breaking and controversial.
Privately known as 'John', she wore men's
clothes, and at a time when male homosexual
behaviour was illegal, she lived, openly, with
singer Mabel Veronica Batten, and later
(1916–43) with sculptor Una, Lady Troubridge.

DAME FREYA STARK

Herbert Olivier, 1923

Oil on canvas, 619 x 555mm • NPG 5465

Courageous explorer and doyenne of travel writers Dame Freya Madeline Stark (1893–1993) ventured into regions – from Syria to southern Arabia – where borders were vague and political forces unpredictable. She was often the first European woman that local people had ever seen. Convinced that the death of her sister Vera in 1926 had been hastened by strictures imposed by others on how she should live, Stark herself vowed to lead her own life, leaving for Lebanon to learn Arabic in 1927. During the Second World War, this enabled her to assist an anti-Axis propaganda campaign. She worked for the British Ministry of Information in Aden, Iraq and Egypt, where she founded the Brotherhood of Freedom. As an authority on the Middle East, she earned awards from the Royal Asiatic Society (in 1934) and the Royal Geographical Society (in 1942), and was created a Dame in 1972. Stark published thirty books during her long career. In her major work *The Valley of the Assassins* (1934), she wrote: 'The great and almost only comfort about being a woman is that one can always pretend to be more stupid than one is and no one is surprised.'

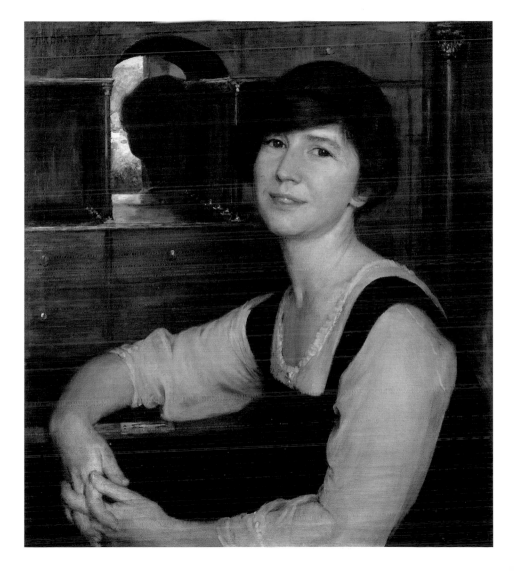

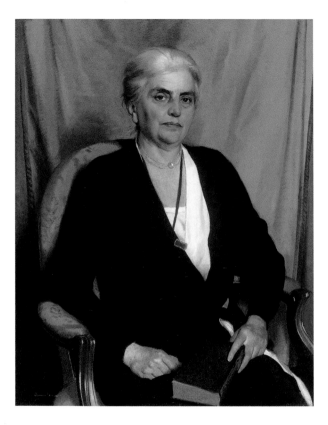

ELEANOR RATHBONE
Sir James Gunn, 1933
Oil on canvas, 918 x 712mm • NPG 4133

Eleanor Florence Rathbone (1872–1946),
social reformer, politician and pioneer of family
allowances, was born in Liverpool. She read
Classics (1893–6) at newly formed Somerville
College, Oxford, and was active in the women's
suffrage movement. As part of Liverpool's
city council from 1909, between the wars she
campaigned especially for housing. Elected an
independent MP in 1929, for the Combined
English Universities, she remained so until this
seat was abolished in 1946. Her reports, *The
Disinherited Family* (1924) and *The Case for Family
Allowances* (1940), were part of her steadfast
campaign for family allowances, introduced in
1945. She was one of five women contributors
to *Our Freedom and its Results* (1936), which
measured progress after enfranchisement,
including developments in the women's
movement, finding much to celebrate, but a
long way to go. Against the appeasement of
Hitler and Mussolini, she helped refugees from
Nazi-occupied Europe. She also campaigned for
women's rights throughout the Commonwealth,
including franchise for Indian women – always
preferring, as her biographer Susan Pedersen
puts it, 'to do good by stealth'.

EMMELINE PANKHURST

Georgina Agnes Brackenbury, 1927

Oil on canvas, 787 x 616mm • NPG 2360

Leading suffragette Emmeline Pankhurst
(1858–1928) gained a lifelong awareness of
women's low status in society, and personal
experience of struggling to stay afloat, on the
sudden death in 1898 of her husband, Richard
Pankhurst, a radical barrister. In 1889, she had
become involved in founding the Women's
Franchise League. Disheartened at creeping
inertia around the cause, in 1903 she established,
with her daughters, Christabel, Sylvia and Adela,
the Women's Social and Political Union (WSPU),
with its motto 'Deeds not Words'. Dubbed
'suffragettes' (by the *Daily Mail*, around 1906),
the WSPU favoured more militancy. Their
tactics, which eventually included arson and
bombing were more public than those of the
'suffragists' – members of the National Union
of Women's Suffrage Societies (NUWSS), which
had been formed in 1897. Between 1908 and
1913, Pankhurst was regularly imprisoned in
Holloway, London, and released after hunger
strikes. The 1918 declaration of suffrage for
women saw her ambition partially realised; 1928,
the year she died, brought the declaration of
equal suffrage for women.

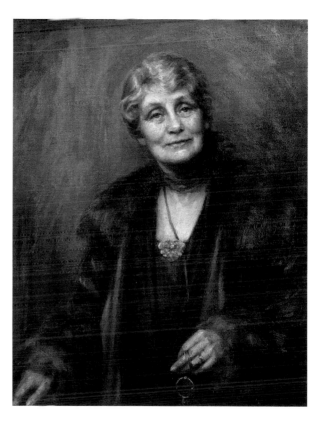

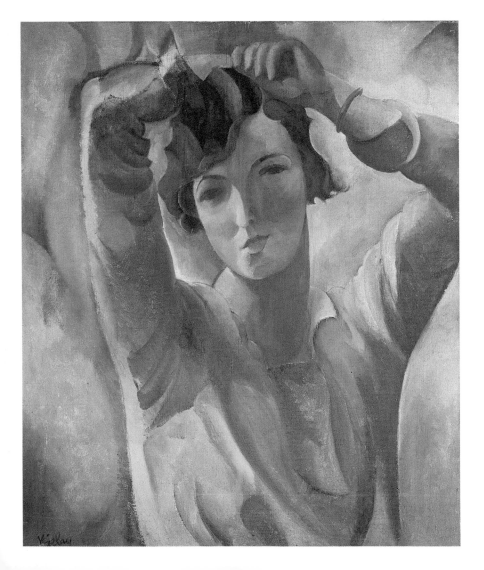

PAULE VÉZELAY

Self-portrait, c.*1927–9*
Oil on canvas, 651 x 543mm • NPG 6003

The painter, etcher, sculptor and book illustrator
Paule Vézelay (née Marjorie Watson-Williams,
1892–1984) was born and brought up in Bristol.
She studied art there and, from 1911, at the
Slade School of Fine Art in London. Her first
solo exhibition, in 1920, was in Brussels: 'English
art then bored me to tears,' she declared. She
settled in Paris in 1926 and changed her name
to Paule Vézelay. Her work became increasingly
abstract. In 1934, she became a member of
Abstraction-Création (an association of abstract
artists that had been established in Paris three
years earlier), and this self-portrait reflects the
pioneering abstract style that Vézelay developed
in the group. A friend of Hans Arp and his wife
Sophie Taeuber-Arp, she exhibited with Arp,
Wassily Kandinsky and Kurt Seligmann in Milan
in 1938. The following year, she returned to
Bristol, producing war-related ink studies and
taking photographs. In the 1950s, she designed
textiles for Heal's department store in London,
and in 1968 enjoyed a retrospective at the
Grosvenor Gallery.

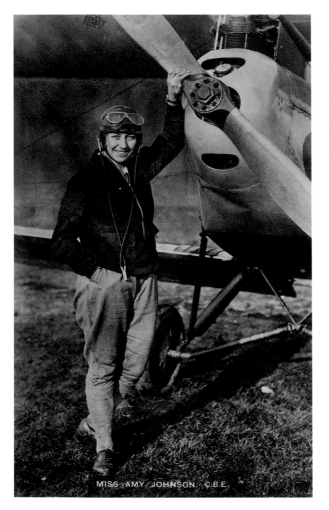

MISS AMY JOHNSON. C.B.E.

AMY JOHNSON
Published by Raphael Tuck & Sons, 1930
Gelatin silver print, 134 x 84mm
• NPG x126240

The aviator Amy Johnson (1903–41), an
Economics graduate, discovered her passion for
flying at the London Aeroplane Club. In 1929,
she qualified as a licensed pilot, and later became
a navigator and the first female Air Ministry
ground-engineer. In 1930, she flew solo in *Jason*,
her De Havilland Gipsy Moth, from Britain to
Australia – the first woman to achieve that feat,
for which she was awarded the Harmon Trophy,
a CBE and a £10,000 prize from the *Daily Mail*.
The aircraft had an open cockpit, no breaks,
lights, heating or fuel gauge. Johnson navigated
the 11,000-mile flight using coastlines, rivers and
landmarks, surviving on three hours' sleep per
night. She undertook further record-breaking
flights: to Tokyo via Siberia (1931) and to Cape
Town (1932), and was awarded, for the latter,
the Segrave Trophy for 'the most outstanding
demonstration of transport on land, sea or air'.
From 1935 to 1937, she was president of the
Women's Engineering Society. For six years from
1932 she was married to the aviator James Allan
Mollison and undertook numerous joint flights
with him. During the Second World War, serving
with the Air Transport Auxiliary, she died bailing
out over the Thames estuary. Despite her tragic
early death, she proved that women could thrive
in what were traditional male fields of endeavour.

MARGARET BONDFIELD

Walter Stoneman, 1930
Gelatin silver print, 160 x 113mm
• NPG x165335

Margaret Grace Bondfield (1873–1953) was
a trade unionist, campaigner for women and
Labour politician, described on a blue plaque in
Chard, Somerset, where she was born, as having
'devoted her life to improving the lot of the
downtrodden'. Her father, a foreman laceworker,
supported working women's rights and
encouraged his daughters in that. Apprenticed
in the drapery trade, Bondfield worked as a
shop assistant, joining the National Union of
Shop Assistants in 1896. Under the pen-name
Grace Dare, she wrote in the Women's Industrial
Council journal, *The Shop Assistant*, and the
Daily Chronicle about shopworkers' dire working
conditions, and rose steadily through various
offices and achievements. In 1899 she was the
sole woman delegate at the annual Trades Union
Congress (TUC); she co-founded the National
Federation of Women Workers, and in 1923
chaired the TUC – the first woman to do so. She
was Labour MP for Northampton (1923–4), then
Wallsend (1926–31), and was appointed Minister
for Labour in 1931 – thereby becoming Britain's
first female cabinet minister. Her extraordinary
career prepared the ground for other women in
public life.

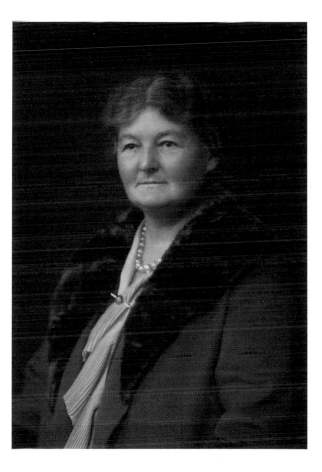

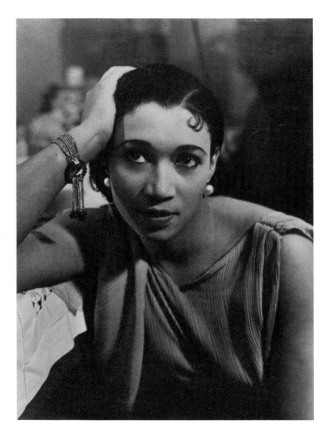

ELISABETH WELCH

Humphrey Spender, 1933
Gelatin silver print, 200 x 147mm
• NPG x14268

Born in New York, the theatre and cabaret
singer Elisabeth Welch (1904–2003) made her
Broadway debut in *Runnin' Wild* in 1923. She
launched the Charleston craze, sang Cole Porter's
'Love for Sale' on the nightclub circuit, appeared
in cabaret in Paris in 1929, and later in London,
in Porter's *Nymph Errant* (1933). A starring role
in Ivor Novello's *Glamorous Night* (1935) secured
her success, which grew when she became the
first black performer to have their own radio
series – *Soft Lights and Sweet Music*, broadcast by
the BBC in 1936 and 1937. In films, from 1934,
she twice played opposite Paul Robeson, and in
1979 appeared in Derek Jarman's *The Tempest*,
performing 'Stormy Weather', which she had
first sung in the all-black review *Dark Doings*
in London in 1933. Broadway's version of her
London hit, *Jerome Kern Goes to Hollywood*, won
her a Tony nomination in 1986. Never overtly
political but always determined, she presents,
according to author and critic Bonnie Greer,
'another pathway … for any young black woman,
any woman, any person who wants to go their
own way in life'.

CORNELIA SORABJI
Lafayette Ltd, 1930
Whole-plate film negative • NPG x70450

In 2016, Somerville College, Oxford, announced a Scholarship in Law for Indian women postgraduates, in honour of Cornelia Sorabji (1866–1954), India's first female lawyer and the first Indian woman to study at Oxford. Sorabji, whose life is a testament to defying gender bias, was Bombay University's first female graduate (1887). After she was refused funding to read law in Britain, supporters, including Florence Nightingale, helped her to do so. Although she was allowed to sit the Civil Law examinations while at Oxford (from 1889 to 1892), she was not able to graduate, as women were ineligible until 1920. (She eventually graduated in 1922.) From 1904, after a decade of struggling with the authorities back in India, she became a government legal adviser for women living in purdah. She was called to the Bar at Lincoln's Inn, London, in 1923 (the year that women were first admitted). Returning to India as a barrister, she resumed her work with 'purdahnashins' (secluded women). Against all odds, she was stalwart in the fight for social reform, her focus on women and the poor.

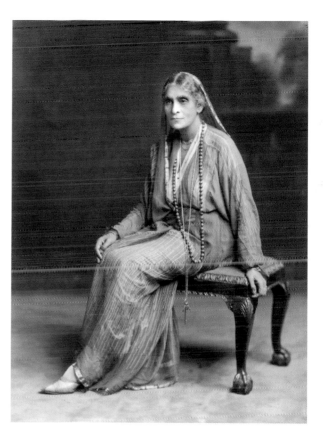

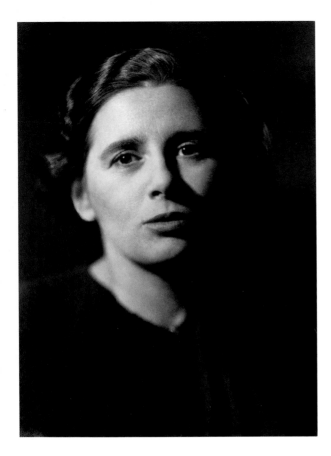

DAME REBECCA WEST
Howard Coster, 1934
Half-plate film negative • NPG x23917

Dame Rebecca West (pseudonym of Cicily
Isabel Andrews, 1892–1983) was a journalist,
novelist, travel writer and critic, her name
a byword for independent women. She had
published pieces in the feminist journal
Freewoman during her teenage years, and in its
first edition wrote in support of free-love, saying
of marriage 'a more disgraceful bargain was
never struck'. Her earliest writing on women's
suffrage was published in the *Scotsman* in 1904,
and she also contributed to the socialist *Clarion*.
Playwright George Bernard Shaw described
her writing as brilliant and savage. Among her
eight novels is *The Judge* (1922), a feminist work
that tackles patriarchy and rape, unmarried
motherhood and suffrage. *Sunflower* (1986)
was based on her affairs with the newspaper
magnate Lord Beaverbrook and the writer
H.G. Wells (with whom she had an illegitimate
child – socially ruinous at the time). Her
writing on the Nuremberg trials, *The Meaning of
Treason* (1949), and Yugoslavia, *Black Lamb and
Grey Falcon* (1941), set her at the forefront of
political commentary. That inspiring frontline
stance was one she held all her life.

ELIZABETH COWELL
Bassano Ltd, 1936
Gelatin silver print, 249 x 198mm
• NPG x84413

'Hello RadiOlympia – this is Direct Television from the studios at Alexandra Palace.' On 31 August 1936, British broadcaster Elizabeth Cowell (1912–98), one of three original BBC Television presenters, made this historic announcement as the world's first female TV announcer. Cowell then introduced singer Helen McKay, in the variety show *Here's Looking at You!* – the first live television programme, broadcast to the radio exhibition at Olympia, London. She was also present when regular television broadcasts began that November – again from Alexandra Palace, north London – and appeared on the front cover of *Radio Times*, above the strapline 'Full Television Programmes Will Begin On Monday', which then meant broadcasting just two hours a day. Having beaten some 1,200 women to the job, her microphone and deportment training, innate friendliness and photogenic glamour enabled her to realise the promise of the 'Television at Last!' newspaper headlines – although some took against her perceived London poshness. During the war, when television broadcasts were suspended, she worked as a BBC radio producer. When TV resumed in the late 1940s, Cowell, by then married, declined to return to announcing.

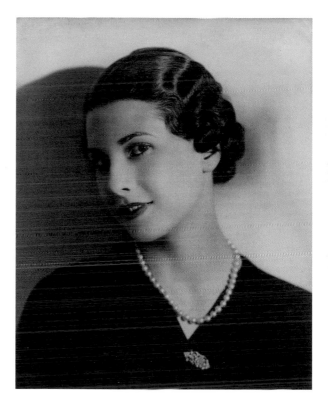

VERA BRITTAIN
Howard Coster, 1936
Gelatin silver print, 241 x 180mm
• NPG x24032

Vera Brittain (1893–1970), writer, pacifist and
feminist, attended Somerville College, Oxford,
in 1914, but left the following year to help
the war effort – first as a nursing assistant in
Derbyshire, then as a nurse with the Voluntary
Aid Detachment. In August 1915, she became
engaged to Roland Leighton. Leighton was a
school friend of her brother Edward, with whom
he had enlisted at the outbreak of war. Both men
were killed in action in France – Roland in 1915
and Edward in 1918. After the war, she returned
to Somerville, becoming friends with Winifred
Holtby, the pair both graduating in 1921. Her
Testament of Friendship (1940) commemorates
their unbreakable bond in a biography of
her great friend and literary ally. But it is her
bestselling autobiography, *Testament of Youth*
(1933), about her harrowing war experiences, for
which she is best known. She joined the Peace
Pledge Union in 1937, no longer 'carried away
by the wartime emotion and deceived by the
shining figure of patriotism' and co-founded the
Campaign for Nuclear Disarmament (CND) in
1957. 'The disadvantages of being a woman have
eaten like iron into my soul,' she once said, but
her life is a more positive testament, in her work
for peace and bettering women's lives.

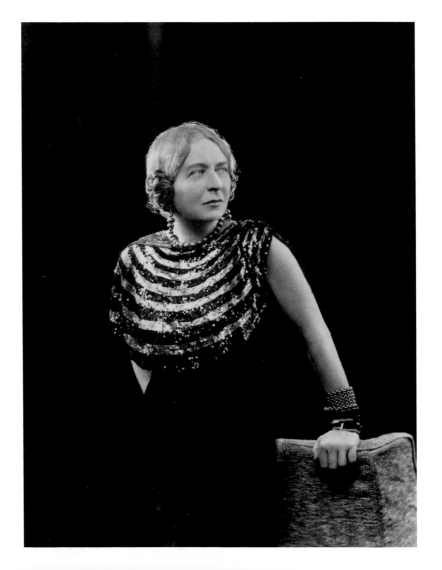

DAME LAURA KNIGHT

Bassano Ltd, 1936
Half-plate glass negative • NPG x19413

In 1936 the painter Dame Laura Knight
(1877–1970) was the first woman fully elected an
Academician of the Royal Academy of Arts (RA),
London, since its foundation in 1768. In 1890,
while at art school, she had noted, 'Women were
not allowed to draw from the nude.' Many years
later, in *Self Portrait* (1913), she depicted herself
painting a full-length nude woman – a defining
work that was refused by the RA and as late as
1939 dismissed by critics as 'regrettable'. She
married artist Harold Knight in 1903, the year
Mother and Child was accepted for the RA summer
exhibition and bought by the painter Edward
Stott, whom Knight admired. A prolific artist,
painter of dancers, gypsies, clowns, the celebrated
and the unknown, she exhibited widely and
internationally. She was elected to numerous
artistic societies and received many awards,
including the honour of a damehood in
1929. The War Artists Advisory Committee
commissioned her to record the Second World
War, and she was appointed war correspondent
for *The Nuremberg Trial* of 1946. Her RA
retrospective of 1965 was a first for a woman –
a reviewer for *The Times*, commenting: 'few
women artists can have delved so widely in
the curiosities of life.'

DAME NINETTE DE VALOIS

Gordon Anthony, 1937

Gelatin silver print, 493 x 377mm

• NPG x44790

Born Edris Stannus in County Wicklow, Ireland,
Dame Ninette de Valois (1898–2001) – known
in the dance world as 'Madam' – was a major
force in twentieth-century ballet. A dancer,
choreographer and teacher, she was the
founder–director of the Royal Ballet and its
national ballet school, which set international
standards. She had started ballet lessons aged
eleven, trained at the Lila Field Academy,
London, and danced with Diaghilev's Ballets
Russes for two years from 1923. In 1926, she
founded the Academy of Choreographic Art –
which became the Royal Ballet in 1956 – and
established other schools, including Abbey
School of Ballet, Dublin, in 1928 and the
Birmingham Royal Ballet in 1946. She helped
launch the career of Prima Ballerina Assoluta
Margot Fonteyn. Among the major ballets she
created were *Job* (1931), *The Rake's Progress* (1935)
and *Checkmate* (1937), to which the background
of this photograph, taken by her brother, refers.
She retired from the Royal Ballet directorship
in 1963, thereafter devoting herself to the school.
She was made a Dame in 1957 and awarded the
Order of Merit in 1992.

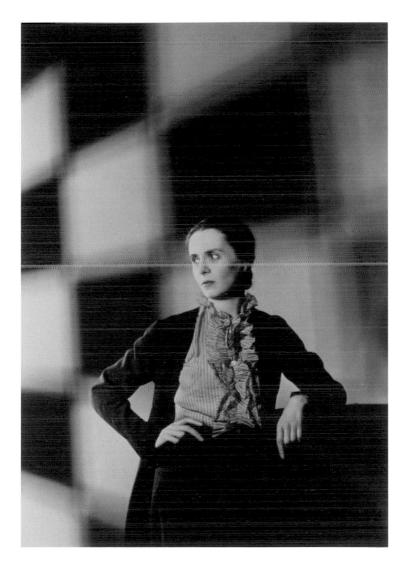

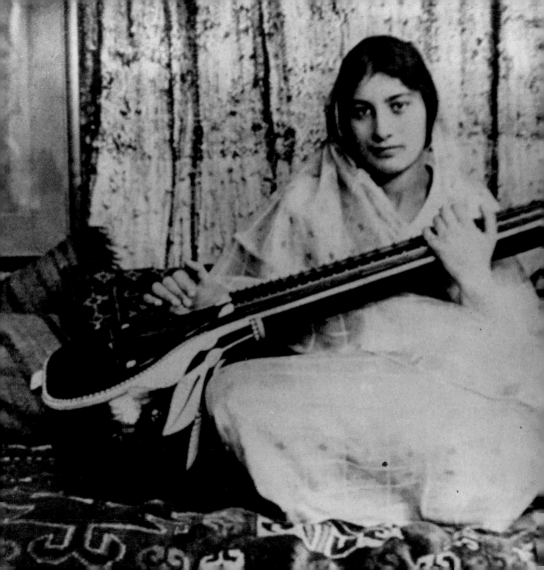

NOOR INAYAT KHAN
Unknown photographer, 1937
Modern gelatin silver print from original
negative,177 x 237mm • NPG x199215

Noor-un-Nisa Inayat Khan (1914–44) was a
special operations officer, a wartime secret
agent. Born in Moscow, of Indian–American
descent, her family moved to London, then
Paris, where she was educated and became a
writer of children's stories. In 1940, she left
Nazi-occupied France for England and joined
the Women's Auxiliary Air Force. In 1942, she
was recruited by Winston Churchill's Special
Operations Executive (SOE) and became the
first female wireless operator infiltrated into
Occupied France. Codenamed Madeleine, she
flew to France in 1943, working with the Prosper
Resistance network in Paris. Despite the arrests
of some members of the network thereafter, she
remained in post. In the autumn of 1943, she was
betrayed and captured by the Gestapo, who had
located her messages and codes. After her brief
escape and recapture, she was tortured – but
revealed nothing. In 1944, she was executed
at Dachau concentration camp. She was
posthumously awarded the George Cross and
the French Croix de Guerre for her war service
and heroism. A memorial to her, unveiled in
Gordon Square Gardens, London, in 2012,
honours her enormous courage and sacrifice.

DAME ROSE HEILBRON
Elliott & Fry, 1949
Gelatin silver print, 158 x 112mm
• NPG x89692

Dame Rose Heilbron (1914–2005), lawyer
and barrister, was the first woman to win a
scholarship to Gray's Inn (1936); to be appointed
silk (1939); one of the first two women (the other
was Helena Normanton) to be king's counsel
in England (1949); the first to lead in a murder
case (1949–50); first woman recorder (1956), for
Burnley; first woman judge at the Old Bailey
(1972) and first woman treasurer of Gray's Inn
(1985). She was also the second woman to be
appointed High Court judge (1974). Jewish and
from modest beginnings (her father managed an
immigrant-refugee lodging house), she graduated
in law from Liverpool University with first-class
honours in 1935. Once called 'the greatest lawyer
in history' by the bookie Jack 'Spot' Comer, for
whom she secured a not-guilty verdict in 1955,
she belonged to Soroptimist International, a
global volunteer movement for human rights and
gender equality that still aims to help women
and girls realise their potential, as she had done.

VIJAYA LAKSHMI PANDIT

Bassano Ltd, 1938
Gelatin silver print, 195 x 144mm
• NPG x84424

Vijaya Lakshmi Pandit (née Swarup Kumari
Nehru, 1900–90), born in Allahabad, was
an Indian diplomat and politician, whose
trailblazing career paved the way for others.
Sister of Jawaharlal Nehru, independent India's
first prime minister, she was imprisoned for
activism during India's independence struggle.
For two years from 1937, she became the first
woman to hold a cabinet position in pre-
Independence India, in the United Provinces
(Uttar Pradesh), and was the leader of the All
Indian Women's Conference from 1941 to 1943.
After the death in prison in 1944 of her barrister
husband, Ranjit Sitaram Pandit, who had
been arrested for Independence activism, she
supported her children alone, since, as a woman,
she had received no inheritance. She was Indian
ambassador in Moscow (1947–9) and in Washington
and Mexico (1949–51). She was also leader of
the Indian UN delegation (1946–8, 1952–3); first
woman president of the UN General Assembly
(1953), and Indian High Commissioner to
London (1954–61). She returned to India, first
as governor (1962–4) to Maharashtra, then as a
member of the parliamentary lower house
(1964–8), and became the Indian representative
to the UN Human Rights Commission in 1978.

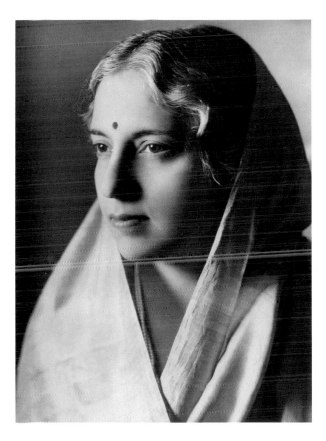

LEE MILLER
David. E. Scherman, 1943
Modern gelatin silver print from original
negative, 254 x 204mm • NPG P1082

Lee Miller (1907–77) was an American-born
photographer and war correspondent. In the
1920s, following a traumatic childhood, she
studied art in New York and in 1927 became a
Vogue cover model, after a chance meeting with
the magazine's publisher, Condé Nast. Her
passion for photography overtook her modelling
career and led her to Paris, where she became
the lover, muse and pupil of the Surrealist Man
Ray. She also befriended Picasso, who painted
her. Back in New York, she opened a portrait
studio, then married a wealthy Egyptian (whom
she later divorced) and moved to Cairo. From
1939, as a photojournalist, she documented the
London Blitz and, attached to the US army
in 1942, became Europe's sole female combat
photographer and correspondent. She recorded
the liberation of the Dachau and Buchenwald
concentration camps, and, famously, was
photographed posing naked in Hitler's bath in
1945. Two years later, in Paris, she married the
English artist Roland Penrose. After her death,
her son, Antony, found thousands of negatives,
prints and contact sheets – a life-affirming record
of her extraordinary achievements.

MADAME YEVONDE
Self-portrait, 1940
Colour dye transfer print, 378 x 305mm
• NPG P620

Madame Yevonde, the professional name
of Yevonde Cumbers (1893–1975), was a
photographer and pioneer in photographic
technique. In 1911, she was apprenticed to society
photographer Lallie Charles, one of the most
commercially successful portraitists of the early
1900s. Three years later, she established her own
studio, developing an experimental approach
to portraiture and undertaking commercial work.
She first exhibited at the Royal Photographic
Society in 1921. Her exhibition at London's
Albany Gallery in 1932 included colour prints,
which, although dismissed as a fad, nonetheless
gained a society following. This self-portrait is
among the last she made using the Vivex colour
process that she championed. At the top is an
image from her iconic colour-portrait series,
Goddesses, in which 1930s socialites adopted
mythological guises: here, the Duchess of
Wellington as Hecate. Through such role-play,
Yevonde explored gender and identity. With
Vivex's demise (from 1945), she turned to black
and white, and explored solarisation, with its
halo-like effects. She remained convinced that
'to be independent was the greatest thing in life'.

ROSALIND FRANKLIN

Vittorio Luzzati, 1950
Gelatin silver print, 229 x 302mm
• NPG x76912

The molecular biologist, chemist and X-ray
crystallographer Rosalind Elsie Franklin
(1920–58) decided to become a scientist aged
fifteen, enrolling at a London girls' school that
taught physics and chemistry. In 1938, despite
her father's resistance (he was against women's
higher education), she attended Newnham
College, Cambridge, graduating in natural
sciences three years later. In 1942, she joined the
British Coal Utilisation Research Association, her
studies there forming the basis of her Cambridge
PhD in physical chemistry, which she gained in
1945. At a chemical-research laboratory in Paris,
she became expert in X-ray crystallography
before returning to England in 1951 to work as
a research associate at King's College, London,
investigating the structure of deoxyribonucleic
acid (DNA). Her work there as a research
assistant was frequently belittled by male peers
and she was barred from the university dining
room and men-only pubs. In fact, during her
time there she produced the images that would
lead Francis Crick and James Watson to reveal
the structure of DNA – a vital contribution that
has been historically overlooked. Her subsequent
work at Birkbeck, University of London, on
tobacco mosaic and polio viruses, ended with her
early death from cancer. When, in 1962, Crick,
Watson and Maurice Wilkins (who had worked
alongside Franklin at King's) were awarded the
Nobel Prize for the discovery of the structure
of DNA, Watson suggested that Franklin might
be included, but by then she had died, and the
prize is not awarded posthumously.

ELIZABETH DAVID
John Stanton Ward, 1956
Ink and wash, 487 x 650mm • NPG 6217

At her OBE award ceremony in 1976, asked by
the Queen what she did, Elizabeth David
(1913–92) responded: 'Write cookery books,
Ma'am.' 'How useful,' came the reply. Indeed,
it was – but, more than that, David's impact was
immense. She introduced Mediterranean
cuisine, ingredients and techniques to post-war
Britain and is credited with completely revitalising
the country's food scene. Her interest in cooking
developed while studying in Paris and travelling
during the Second World War. On returning
to England in 1946, she began to write about
cookery, and in 1949 was offered a column in
Harper's Bazaar. *A Book of Mediterranean Food*
(1950) launched her career. Four similarly
influential books came out in the following
decade – on French country, French provincial,
Italian and summer cooking. Her urbane style –
which she dismissed as 'my amateur's efforts
at writing' – was refreshing and welcome,
and despite post-war rationing, her success
acknowledged the British, as she put it, as 'more
creative and enquiring about cooking than they
have ever been before'.

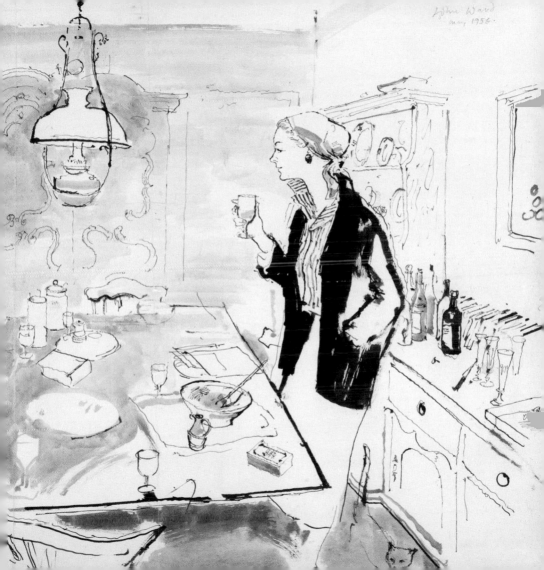

John Ward
May 1956.

STELLA ISAACS,
MARCHIONESS OF READING

Sir James Gunn, 1961–2

Oil on canvas, 1120 x 914mm • NPG 6833

Stella Isaacs (also Baroness Swanborough, 1894–1971), philanthropist and founder–chair of Women's Voluntary Service (WVS; later Royal Voluntary Service), was born in Constantinople, where her father worked for the British Foreign Service. Having trained as a secretary in 1914, she later joined the Viceroy's secretariat in Delhi, India, before marrying Rufus Isaacs, 1st Marquess of Reading, in 1931. Increasingly drawn to voluntary social work, it was her involvement with the Personal Service League, formed for those in need and unemployed, that led the home secretary Sir Samuel Hoare to invite her to form the WVS in 1938. Although its original purpose had been air-raid precautions, by 1942, the WVS had mobilised more than a million women to help with the evacuations, care of refugees and bomb victims, and armed-forces welfare provision. She served as vice-chair of the Imperial Relations Trust (1936–68), a governor of the BBC (1947–52) and chair of the Commonwealth Immigrants Advisory Council (1962). She was appointed DBE in 1941, GBE in 1944 and created Baroness Swanborough in 1958 – the first woman to receive a life peerage.

DAME MARY QUANT

Keystone Press Agency Ltd, c.1965
Gelatin silver press print, 252 x 194mm
• NPG x194166

Dame Mary Quant (b.1934), fashion designer
and retail pioneer, was born in London and
studied illustration at Goldsmiths College.
In 1953, she was apprenticed to the upmarket
Mayfair milliner Erik of Brook Street. Two years
later , she began to design and make clothes,
often producing new stock overnight, with the
opening of her boutique, Bazaar, on King's
Road, London. Co-founded with future husband
Alexander Plunket Greene (whom she married
in 1957) and friend Archie McNair, Bazaar was
one of the first retail outlets aimed specifically
at young people. With its wacky window displays,
loud music and late opening hours, the shop
sold affordable clothes in simple shapes with
geometric designs and vibrant colours. In 1967,
the *Guardian* reported Quant as saying: 'Good
taste is death. Vulgarity is life.' She ushered in
a style era that encouraged people to dress for
themselves, helping to revolutionise British
fashion. She popularised the miniskirt, high
hemlines and the other similar looks that defined
the Swinging Sixties and beyond. In 1966, she
received an OBE for services to fashion, and
was made a Dame in 2015.

JACQUELINE DU PRÉ
Sefton Samuels, 1969
Gelatin silver print, 230 x 294mm
• NPG x129512

Although her playing career ended when she
was twenty-seven, Jacqueline du Pré (1945–87)
is considered one of the most distinctive
cellists of the twentieth century, known for the
innovative physicality of her playing and her
emotional performances. In 1956, she won the
prestigious Guilhermina Suggia scholarship,
studying with William Pleeth at the Guildhall
School of Music, London. (She would later
study with Tortelier, Casals and Rostropovich.)
She was awarded the Guildhall Gold Medal and
Queen's Prize in 1960, and made her official
debut at London's Wigmore Hall the following
year. Her first professional concert with orchestra
was in 1962 – playing Elgar's *Cello Concerto*,
the work for which she become best known.
Her stature as a great musician of international
standing was established in 1965, with a US tour
and an EMI recording of the Elgar concerto
under John Barbirolli. Following the Soviet
invasion of Czechoslovakia, in 1968, she and
pianist–conductor Daniel Barenboim (whom she
had married in 1967) played a benefit concert,
despite death threats. In 1973, a diagnosis
of multiple sclerosis cut short her career as a
performer, although she continued to teach. She
was made Honorary Fellow of St Hilda's College,
Oxford, the city of her birth. The college's Music
Building bears her name – a fitting legacy to an
inspiring career of blazing intensity.

OLIVE ELAINE MORRIS
Neil Kenlock, 1973
Gelatin silver print, printed later,
381 x 254mm • NPG x199645

Olive Morris (1952–79) was a political activist
and community leader, based in and around
the counter-cultural hub of Brixton in London.
Arriving from Jamaica, aged nine, she became
politicised in the 1960s and 1970s, when stop-
and-search ('sus') laws and discrimination in
housing and employment made life extremely
difficult for the African-Caribbean community.
Morris was indefatigable in her fight against
oppression, against not just racism but also
sexism. For example, in 1969, she received a
three-month suspended sentence for interceding
in a Nigerian diplomat's arrest for a parking
offence. Having been physically and racially
abused by the police during this incident,
she joined the revolutionary socialist Black
Panthers in the 1970s and became a founder-
member of the Brixton Black Women's Group.
From 1973 she squatted at 121 Railton Road,
Brixton – where this photograph was taken –
which evolved into a centre (until 1999) for the
squatting movement and for community groups,
such as Black People against State Harassment.
From 1975 to 1978, Morris read economics and
social science at Manchester University, where
she campaigned against overseas-students' fees
and was active in the Manchester Black Women's
Co-operative and the Black Women's Mutual
Aid Group. Thereafter, she worked in Brixton
Community Law Centre's juvenile unit, where
she was involved in scrapping the 'sus' laws. She
cofounded the Organisation of Women of African
and Asian Descent in 1978. Her fight against
oppression continues, long after her premature
death from cancer.

MARGARET THATCHER, BARONESS THATCHER OF KESTEVEN

Clay Perry, 1974
Colour coupler print, 455 x 302mm
• NPG x136993

Margaret Thatcher (1925–2013), Conservative politician, was the first woman to lead a major UK political party and, following victory in the General Election of 1979, the country's first female prime minister (she was re-elected twice, in 1983 and 1987). The daughter of a grocer, she was educated at Kesteven & Grantham Girls' School and Somerville College, Oxford. Her first career was as a research chemist (1947–51), her second as a lawyer (she was called to the Bar in 1954), before beginning her parliamentary career as MP for Finchley five years later. She was dubbed 'Milk Snatcher' for removing free school milk for children over seven when Education Secretary in 1971, and 'Iron Lady' by a Soviet newspaper in 1976 – a sobriquet she embraced. Her premiership was characterised by tough economic policies that included privatising industries and closing coal mines, and military engagement in the Falklands War (1982). The year of this photograph IRA bombs killed and injured many – and she herself became a target in 1984. 'I fight on. I fight to win,' she declared in 1990, after an inconclusive first ballot in the Tory leadership election that she lost – signalling a determined character and distinguished, though highly controversial, political career.

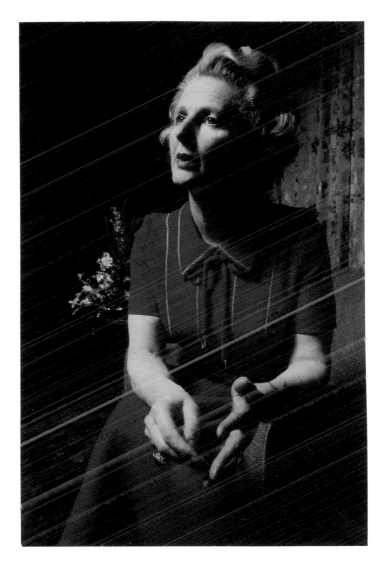

DOROTHY HODGKIN
Maggi Hambling, 1985
Oil on canvas, 932 x 760mm • NPG 5797

The chemist and crystallographer Dorothy Mary
Hodgkin (1910–94) is the only British woman
to have won a scientific Nobel Prize (in 1964).
Born in Cairo, she developed an early interest
in chemistry and crystals – and, at school in
England was one of only two girls permitted to
study chemistry. She read chemistry, with a focus
on crystallography, at Somerville College,
Oxford, graduating in 1932 with a first. In 1935,
after working as a research student at Cambridge,
she gained her PhD. She returned to Oxford
to take up a Fellowship, later becoming the first
Somerville Fellow to start a family in post – and
the first at the University to receive maternity
pay. She was the first scientist to make an X-ray
diffraction photograph of a protein, a technique
that she subsequently used to define the structure
of penicillin (1942–4), vitamin B_{12} (1964) and
insulin (1969). Her many distinctions include
Fellowship of the Royal Society (in 1946), the
award of its royal medal (in 1956) and receipt
of the Order of Merit (in 1965) – one of the UK's
highest honours. The Royal Society's Dorothy
Hodgkin Fellowship offers support to those with
parenting or caring responsibilities embarking on
a scientific research career. In 1999, Somerville
inaugurated annual memorial lectures in her name.

NAOMI CAMPBELL

Patrick Demarchelier, 1987
Colour coupler print, 1158 x 865mm
• NPG x199692

London-born Naomi Campbell (b.1970) attended stage school, aged five, and worked in television and on music videos before signing with a model agency in 1985. She appeared on the cover of British *Elle* (1985) then British (1987), Italian (1988) and American (1989) *Vogue*. She was the first black cover model for French *Vogue* in 1988. Her early experiences of performing and auditioning led to a sense of being overlooked: 'I understood what it meant to be black. ... You had to be twice as good.' An original 1990s supermodel, she has fronted high-profile campaigns for prestige couture houses, and stands against racism and for diversity in her industry. Her advice, reported by *Elle*, to those insecure in an industry that seems not to value them: 'Do not give up or give in.' A contributor to British *GQ*, *Interview* and other magazines, as well as, from 2017, contributing editor to British *Vogue*, she also fundraises for the Nelson Mandela Children's Fund and is a spokesperson for Fashion for Relief.

HELEN BROOK, LADY BROOK

Nick Sinclair, 1992
Gelatin silver print, 460 x 353mm
• NPG P510(6)

Helen Grace Mary Brook (1907–97), birth-control advocate and family-planning adviser, first worked as a volunteer for the Family Planning Association. In 1958, she was invited to run an independent family-planning clinic in London, where she started weekly evening sessions for unmarried women refused advice at other clinics. In 1964, she founded the first Brook Advisory Centre for women and men, young or unmarried, which opened in London, initially to opposition but later gaining medical-establishment support. Her primary aim was to reduce illegal abortion and inculcate a sense of sexual responsibility. She was a pragmatist, not condoning promiscuity but aware of how sexual attitudes and practices were evolving. As she explained in a *Telegraph* interview for her seventy-ninth birthday: 'I felt that, until women were free of the fear of unwanted pregnancy, they would not be able to take up the equal opportunity of work.' She was awarded a CBE in 1985.

BARBARA CASTLE, BARONESS CASTLE OF BLACKBURN

Nick Sinclair, 1992
Gelatin silver print, 456 x 351mm
• NPG P510(8)

The Labour politician Barbara Anne Castle (1910–2002) was the party's 'Red Queen', and, for very many years, the woman MP with the longest continuous service (a title currently held by Harriet Harman). Educated at Bradford girls' grammar school then Oxford, she became a committed socialist who wished 'to inch people towards a more civilised society'. Determined on a political career, after a spell in the civil service, in 1945 she was elected MP for Blackburn. Harold Wilson gave her a cabinet post when Labour was returned to power in 1964. She was Minister of Transport from 1965 to 1968 and Secretary of State for Employment and Productivity from 1968 to 1970. After leaving the Commons in 1979, she spent ten years as the MEP for Manchester, before her elevation to the House of Lords, where her continued activism (on pensions) caused the then chancellor Gordon Brown to call her 'my mentor and my tormentor'. She appeared on the BBC *Woman's Hour* Power List 2016. The judging-panel chair Emma Barnett said, of Castle's introduction of the Equal Pay Act 1970, arguably her greatest achievement: 'It would be criminal not to [include] Barbara Castle … Every negotiation I've ever had I know I've got her standing behind me with what she put into legislation.'

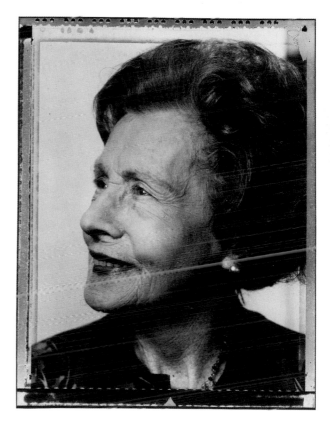

GERMAINE GREER

Paula Rego, 1995
Pastel on paper laid on aluminium,
1200 x 1111mm • NPG 6351

Germaine Greer (b.1939) is an Australian
academic, writer and broadcaster; a major voice
of second-wave feminism. After university
in Melbourne (where she was born) and
Sydney (where, while studying for an MA,
she was briefly involved with bohemian
anarchists the Push), she completed a PhD
in English Literature (1964–7) at Newnham
College, Cambridge. While lecturing at the
University of Warwick (1967–72) she wrote
the hugely influential feminist text, *The Female
Eunuch* (1970) – expecting, she said, 'that
most people would disagree'. It became an
international bestseller. Other intellectually
significant works, ranging from *Sex and Destiny*
(1984) to *Shakespeare's Wife* (2007), followed.
White Beech (2013), about her restoration of an
Australian rainforest, highlighted her work as
an environmentalist. Paula Rego's depiction
of her is a powerful example of contemporary
portraiture – vigorous and straightforward but
monumental. Greer's hands are rough from
the gardening that she enjoys – and the lack of
flattery appeals to her: 'a portrait that is kind is
condescending'.

DAME STELLA RIMINGTON

Bob Beaumont, 1996
Gelatin silver print, 253 x 173mm
• NPG x87560

Stella Rimington (b.1935) was the first female
Director General (DG) of the UK Security
Service, MI5 – a post she held from 1992 to 1996
– and its first head to be publicly named (in 1993).
After joining MI5 in 1969, she worked in all
three main branches – counter-subversion,
counter-espionage and counter-terrorism –
becoming the first woman to be promoted
director of a Service branch. Her years there
coincided with great external change, from the
Cold War to the miners' strike. Equally, they
were times of huge internal change within MI5,
in that it had been customary when she was
initially recruited for women to be barred from
intelligence or operational work. When her
leadership of the organisation became known,
she was given the absurd tabloid label 'housewife
superspy' and was even photographed en route
to work, in a new spirit of openness. Upon her
retirement in 1996, she was appointed Dame
Commander (DCB), and has since written her
autobiography, *Open Secret* (2001) and several
bestselling novels. In 2011, she was chair of the
Man Booker Prize judging panel.

JOCELYN BELL BURNELL
Julia Hedgecoe, 1997
Gelatin silver print, 293 x 391mm
• NPG P751(3)

Jocelyn Bell Burnell (b.1943) is an astrophysicist, best known for the discovery of pulsars – rotating neutron stars that appear to pulse as the beam of light they emit can only be seen when it faces the Earth. She made the finding, considered to be one of the greatest astronomical discoveries of the twentieth century, while still a postgraduate, and despite being named in the research paper, it was Bell Burnell's supervisor, Antony Hewish, and another researcher, Martin Ryle, who went on to win the 1974 Nobel Prize in Physics for their work. Between 2002 and 2004, Bell Burnell served as president of the Royal Astronomical Society, the second woman to hold the post in the institution's almost 200-year history. She was the first female president of the Institute of Physics and in 2015 she won the Royal Society's Royal Medal for her contribution to the observation and understanding of pulsars. She has spoken about the need for a 'culture change' in the English-speaking world to enable and encourage young women to get involved in STEM (science, technology, engineering and mathematics) subjects.

KATE ADIE
Harry Borden, 2002
Colour coupler print, 455 x 358mm
• NPG x128163

Kate Adie (b.1945) is a journalist and former chief news correspondent for the BBC. After graduating in Scandinavian Studies from Newcastle University, she began her career in local radio for the BBC and soon became a reporter for national television news. In 1980, she reported live and unscripted while crouched behind a car door during the siege of the Iranian Embassy in London and subsequently became well known for reporting from war zones, one of only a few women doing so at the time. Adie covered events including the American bombing of Tripoli in 1986, the Tiananmen Square protests in 1989, the Gulf War, and the Rwandan genocide in 1994. Since 1998, she has presented BBC Radio 4's *From Our Own Correspondent*, a platform for correspondents, journalists and writers from around the world to report on current events and topical themes.

TANNI GREY-THOMPSON, BARONESS GREY-THOMSON

Carolyn Djanogly, 1998
Gelatin silver print, 504 x 409mm
• NPG x125652

Tanni Grey-Thompson (b.1969) is a former British wheelchair racer and parliamentarian. Born with spina bifida, she has been a wheelchair user since the age of eight, and at seventeen years old became part of the British Wheelchair Racing Squad. Over the course of her sporting career she competed at five Paralympic Games and won twenty-nine Paralympic and World Championship medals in a number of racing disciplines. Between 1992 and 2002, she also won the London Marathon six times. Throughout her career she has worked extensively to gain equal rights for disabled people and has sat on the boards of the National Disability Council, Sports Council for Wales and UK Sport, among others. Since 2010, she has been a crossbench peer in the House of Lords and has spoken on issues including disability rights, welfare reform and sport.

DAME CICELY SAUNDERS

Catherine Goodman, 2005
Oil on canvas, 912 x 707mm • NPG 6704

Dame Cicely Saunders (1918–2005) was
a physician, writer and pioneer of modern
palliative care. While working as a medical social
worker in the 1940s, she was involved in the
care of patients with incurable illnesses and,
shortly after qualifying as a doctor, was awarded
a research scholarship to study pain management
in the terminally ill. Saunders formulated
the concept of 'total pain', encompassing
the physical, emotional, spiritual and social
dimensions of distress and, in 1967, went on
to found St Christopher's Hospice, the first
purpose-built hospice in the world. In 2002,
she set up Cicely Saunders International, a charity
that seeks to promote research to improve
the care and treatment of all patients with
progressive illnesses and those at the end of life.

DAME CAROL ANN DUFFY

Peter Everard Smith, 2005

Colour coupler print, 312 x 449mm

• NPG x134329

Dame Carol Ann Duffy (b.1955) is a poet, playwright and children's writer. In 2009, she succeeded Andrew Motion as Britain's Poet Laureate, and in doing so became the first woman, Scot and openly LGBT person to hold the position in its 400-year history. Her poetry collections include *Standing Female Nude* (1985); *Selling Manhattan* (1987), which won the Somerset Maugham Award; *Mean Time* (1993), winner of the Whitbread Poetry Award and Forward Prize; and the T.S. Eliot Prize-winning *Rapture* (2005). Oppression, gender, love and violence are key themes in her writing, and her poems are regularly studied in schools. As a playwright, Duffy's work has been performed at the Liverpool Playhouse, Almeida Theatre, London, and the National Theatre.

DAME ZAHA HADID

Michael Craig-Martin, 2008

Wall-mounted LCD screen with integrated
software, 1257 x 749mm • NPG 6840

Dame Zaha Mohammad Hadid (1950–2016) was
an Iraqi-British architect and founder of Zaha
Hadid Architects. Sometimes referred to as the
'Queen of the curve', her work is characterised
by bold, visionary forms, and her buildings can
be seen all over the world. The London Aquatics
Centre (built for the 2012 Olympic Games),
the Rosenthal Center for Contemporary Art in
Cincinnati and the Guangzhou Opera House in
China are among her most renowned projects.
In 2004, Hadid became the first woman to
receive the prestigious Pritzker Architecture
Prize. She won the RIBA Stirling Prize in 2010
and 2011, for the Maxxi Museum, Rome, and
Evelyn Grace Academy, London, respectively.
In 2016, shortly before her death, she became
the first individual female recipient of the Royal
Gold Medal, awarded annually since 1848 by the
Royal Institute of British Architects.

KANYA KING

Bryan Adams, 2008
Colour coupler print, 520 x 390mm
• NPG x131979

Born in Kilburn, London, Kanya King is
the founder and CEO of the Music of Black
Origin (MOBO) Organisation. She set up
the organisation to recognise the outstanding
achievements of artists performing music in
genres ranging from gospel, jazz, R&B, soul and
reggae to hip hop. She launched the MOBO
Awards in 1997, re-mortgaging her house to fund
it, and a year later she negotiated distribution
rights for the event to be broadcast worldwide.
Since then, the annual awards show has hosted
some of the music industry's best-known
artists. The MOBO Trust, the organisation's
charitable arm, works to advance education in
the performing arts among children and young
people from diverse backgrounds.

DAME ATHENE DONALD

Anne-Katrin Purkiss, 2010
Gelatin silver print, 300 x 237mm
• NPG x135636

The physicist Dame Athene Donald (b.1953)
is a champion of women in science and a
Fellow of the Royal Society. Much of her career
has been spent researching soft matter and
biological physics and she has published widely
in this field. She is Professor of Experimental
Physics at the University of Cambridge and,
in 2014, became Master of Churchill College,
Cambridge. In 2009, she was named a Laureate
at the L'Oréal-UNESCO Awards for Women
in Science and won the Faraday Medal of the
Institute of Physics the following year. From
2009 to 2013, Donald chaired the Athena Forum,
an independent committee that aims to improve
the situation for women in science, technology,
engineering, mathematics and medicine in UK
higher education. From 2010 to 2014, she was
the University of Cambridge's Gender Equality
Champion. In 2010, she was made a DBE for
services to physics, and three years later received
a Suffrage Science Award from the Medical
Research Council.

BARBARA JUDGE, LADY JUDGE

Alexander McIntyre, 2010

Colour coupler print, 290 x 292mm

• NPG x135765

Barbara Judge (b.1946) is an American–British lawyer and businesswoman. She began her career in corporate law, and in 1980, at the age of thirty-three, became the youngest-ever commissioner at the US Securities Exchange Commission. In this role, she was influential in the decision to open up the Tokyo Stock Exchange to foreign members. She went on to become the first woman to be appointed executive director of a British merchant bank and was also the first female executive director at News International. She has served in a number of other executive and non-executive roles and, in 2004, was named Chairman of the United Kingdom Atomic Energy Authority. In 2010, she took up a position as Chairman of the Pension Protection Fund and that same year was awarded a CBE for services to nuclear and financial industries. In 2015, she became the first female Chairman of the Institute of Directors, an organisation where, at that time, less than fifteen per cent of its members were women.

BRENDA HALE,
BARONESS HALE OF RICHMOND

Anita Corbin, 2010

Colour coupler print, 455 x 304mm

• NPG x137419

Brenda Hale (b.1945) began her career as an assistant lecturer in Law at the University of Manchester, working part-time as a barrister. She was the first woman, and youngest person, to be appointed to the Law Commission. Among other reforms, she oversaw the introduction of the Children Act 1989, considered one of the most important pieces of legislation affecting children. Hale became Professor of Law at Manchester in 1986. In 1994, she became a High Court judge and, in 1999, she was the second woman to be appointed to the Court of Appeal. She was Great Britain's first female Law Lord, the first female justice of the Supreme Court and, as of 2017, its first female president. She has spoken publicly about the need for increased diversity in the judiciary and, when appointed to the House of Lords, the coat of arms she created bore the motto 'Omnia Feminae Aequissimae', meaning 'women are equal to everything'.

HELEN BAMBER

Nancy Honey, 2012
Inkjet print, 320 x 484mm • NPG x137961

Helen Bamber (1925–2014) was a psychotherapist and human rights activist. In her late teens, she found work as a secretary and administrator to the National Association of Mental Health (now Mind), which treated soldiers and airmen returning from war. At the age of twenty, Bamber volunteered for the Jewish Relief Unit and was sent to the Nazi concentration camp of Bergen-Belsen, following liberation, to work with Holocaust survivors. She remained there for two years. She was subsequently appointed to the Committee for the Care of Children from Concentration Camps and assisted in the care of 722 orphans who had been incarcerated at Auschwitz concentration camp. She helped establish the first medical group at Amnesty International, and, in 1985, she founded the Medical Foundation for Victims of Torture. At the age of eighty, she founded the Helen Bamber Foundation to expand her work with torture survivors and to provide care, safety and dignity to victims of all forms of human rights violations. Bamber was named European Woman of Achievement in 1993 and awarded an OBE in 1997.

NICOLA ADAMS

Kate Peters, 2012
Colour coupler print, 508 x 407mm
• NPG P1831

Nicola Adams (b.1982) was the world's first
woman to win an Olympic gold medal in boxing,
at London 2012, the first Games to include
female competitors in every sport. In 2016,
in Rio de Janeiro, she became the first British
boxer since 1924 to retain an Olympic title.
When she began training, the Amateur Boxing
Association of England had still not ended its
ban on women boxing, which had stood for over
a century. It was lifted by vote in 1996 and, five
years later, Adams became the first woman boxer
to represent England. She was a European silver
medallist in 2007 and World Championship
silver medallist a year later. Openly bisexual, she
was named the most influential LGBT person
in Britain by the *Independent* in 2012. She was
awarded an MBE in 2013.

MALALA YOUSAFZAI

Julian Broad, 2013

Gelatin silver print, 453 x 302mm

• NPG x199266

Malala Yousafzai (b.1997) is a Pakistani activist for female education. Born in the Swat Valley, Pakistan, she came to prominence in 2009, with a blog she wrote under a pseudonym for BBC Urdu that shed light on her life as a schoolgirl under Taliban occupation. She was nominated for the International Children's Peace Prize by Desmond Tutu in 2011 and her profile rose once more when she was awarded Pakistan's first National Youth Peace Prize later that year. In 2012, Yousafzai was shot by a Taliban gunman as she travelled home by bus after taking an exam. She was eventually transferred to hospital in Birmingham for medical treatment. In 2013, on her sixteenth birthday, Yousafzai spoke at the United Nations – her first public appearance since the attack – to call for worldwide access to education. Yousafzai won the Nobel Peace Prize in 2014, becoming the youngest-ever Nobel Laureate. The Malala Fund, an organisation she co-founded with her father, supports the education of girls in countries where access to it is limited or restricted. Yousafzai is now based in the UK.

DOREEN LAWRENCE, BARONESS LAWRENCE OF CLARENDON

Suki Dhanda, 2013

Colour coupler print, 507 x 407mm

• NPG x199083

Doreen Lawrence (b.1952) is a campaigner and founder of the Stephen Lawrence charitable trust. Born in Jamaica, she was nine when her family emigrated to the UK. She came to public attention in 1993, following the racially aggravated murder of her son, Stephen, at a bus stop in south-east London. She and her then husband, Neville, campaigned to bring their son's killers to justice and were critical of police handling of the case, claiming that incompetence and racism were hampering the investigation. Their campaigning and criticism resulted in a judicial inquiry in 1999 and generated headlines when it concluded that institutional racism in the Metropolitan Police was a primary cause in the failure to solve the case. Lawrence has since continued to work to secure reform in the police service and was awarded an OBE for services to community relations in 2003. In 2013, she was made a life peer in the House of Lords.

HALEH AFSHAR,
BARONESS AFSHAR

Nancy Honey, 2014

Inkjet print, 480 x 320mm • NPG x137712

Haleh Afshar (b.1944) is an expert in Middle Eastern affairs, a professor of politics, women's studies and Islamic law, and a cross-bench peer in the House of Lords. Afshar spent her early childhood in Iran and Paris. She moved to Britain to attend boarding school at the age of fourteen, despite not knowing how to speak English. She attended university in the UK before returning to Iran in her late twenties, working as a civil servant on land reform and as a journalist. She has written extensively on Iran and Iranian politics and has edited a number of books on women and development. She has held many posts with public and governmental bodies and served as Deputy Chair of the British Council's Gender and Development Task Force for seven years. Afshar was awarded an OBE in 2005 for services to equal opportunities and was made a baroness two years later.

BETTY BOOTHROYD, BARONESS BOOTHROYD

Brendan Kelly, 2014

Oil on canvas, 1003 x 1002mm • NPG 6982

Betty Boothroyd (b.1929) was the first female
Speaker of the House of Commons from 1992
to 2000. Born in Yorkshire, her parents were
textile workers. In the 1940s she worked as a
dancer with the Tiller Girls. She was assistant to
Barbara Castle MP from 1956 to 1958 and moved
to the United States to observe the Kennedy
administration in the early 1960s. Returning to
London, she entered local politics, having been
elected to a seat on Hammersmith Borough
Council. She stood as an MP on a number of
occasions and, in 1973, was eventually elected
in a by-election as MP for West Bromwich.
Boothroyd served as a Member of the European
Parliament from 1975 to 1977 and as Chancellor
of the Open University from 1994 to 2006. She
was created a life peer in 2001.

LEYLA HUSSEIN

Jason Ashwood, 2015
Gelatin silver print, 364 x 242mm
• NPG x199650

Leyla Hussein (b.1980) is a psychotherapist
and social activist. In 2010, with fellow
psychotherapist Nimco Ali, she co-founded
Daughters of Eve, a non-profit organisation
dedicated to ending gender-based violence,
including female genital mutilation (FGM).
Hussein was seven years old when she
underwent the procedure and refers to herself
as a 'survivor' rather than a victim. She has
spoken publicly about the verbal threats and
intimidation she has received as a result of her
campaigning work. In 2014, she gave evidence
to the Home Affairs Select Committee about
the practice of FGM in the UK. She has won
numerous awards for her work. *The Cruel Cut*, an
hour-long documentary that Hussein produced
for Channel 4, was nominated for a BAFTA.

LIBBY LANE

Peter Kindersley, 2016

Colour coupler print, 506 x 339mm

• NPG x199739

Elizabeth Jane Holden 'Libby' Lane (b.1966) was the first woman to be appointed a bishop by the Church of England, after a vote in the General Synod in July 2014 paved the way. She was consecrated as Bishop of Stockport at York Minster on 26 January 2015 and installed at Chester Cathedral on International Women's Day (8 March) in 2015. Her appointment, more than twenty years after women were first admitted to the Church of England as priests, was seen as an important step towards greater equality in the Church's senior ranks, but her consecration was briefly interrupted by Anglo-Catholic priest Paul Williamson, who considered Lane's appointment contrary to the teachings of the Bible and her being a woman an 'absolute impediment'. Before becoming a bishop, she was elected as one of eight clergywomen from the Church as participant observers in the House of Bishops, of which she is now a full member.

MAGGIE ADERIN-POCOCK

Simon Frederick, 2016

Inkjet print, 380 x 260mm

• NPG P2058

Maggie Aderin-Pocock (b.1968) is a leading
space scientist and the presenter of *The Sky
at Night*. It was the television series *Clangers*
that, she says, first stimulated her interest in
space. Born in London to Nigerian immigrants,
Aderin-Pocock attended thirteen schools as a
child and was diagnosed with dyslexia. She built
her first telescope at the age of fifteen and went
on to receive a BSc in Physics and a PhD in
Mechanical Engineering from Imperial College,
London. After graduating, she worked for the
Ministry of Defence on projects ranging from
missile warning systems to landmine detectors.
She subsequently returned to her first passion:
building instruments to explore space, including
a spectrograph for the Gemini Observatory in
Chile that allowed scientists to analyse the light
of stars and gain insights into their properties,
and optical equipment for the James Webb
telescope (the planned successor to the Hubble
telescope). Alongside her academic work,
Aderin-Pocock is committed to inspiring new
generations of space scientists and engineers,
and runs her own company, which engages with
children and adults around the world.

MILESTONES

A selection of 'firsts' for British women and milestones on the road to equality in the UK.

1553 – Mary Tudor becomes the first queen regnant of England.

1667 – Margaret Cavendish is the first woman to attend a meeting of the Royal Society.

1750s – Elizabeth Carter and Elizabeth Montagu help to establish the Bluestocking Circle.

1768 – Angelica Kauffmann and Mary Moser are the two female founder-members of the Royal Academy of Arts.

1818 – Elizabeth Fry is the first woman to present evidence to Parliament, to a committee on British prison conditions.

1821 – Fry forms the British Ladies' Society for the Reformation of Female Prisoners, one of Britain's first women's organisations.

1865 – Elizabeth Garrett Anderson is the first woman to qualify in Britain as a physician and surgeon. (In 1908 she became England's first female mayor – of Aldeburgh, Suffolk.)

1867 – London Society for Women's Suffrage is formed to campaign for female voting rights.

1870 – Married Women's Property Act allows married women to own their own property.

1897 – Rachel Beer becomes the first woman to edit a British national broadsheet newspaper – the *Observer*.

1897 – National Union of Women's Suffrage Societies is set up.

1900 – Charlotte Cooper, from London, becomes the first woman to win an Olympic gold medal – for tennis.

1903 – Women's Social and Political Union is set up by Emmeline Pankhurst, her daughters Christabel and Sylvia, and Annie Kearney, in Manchester.

1906 – National Federation of Women Workers is founded by Mary MacArthur.

1908 – Edith Morley becomes the first professor at a UK university-level institution, with her appointment to the chair of English Language at the University of Reading. (In 2017 the Royal Conservatoire of Scotland found that Emma Ritter-Bondy may have achieved that status earlier, having been appointed Professor of Piano there in 1892.)

1912 – 'Cat and Mouse' Act allows the government to temporarily release women prisoners who are hunger striking for the vote – until they are fit enough to be imprisoned again.

1915 – Edith Smith becomes Britain's first woman police constable with official powers of arrest. The first Women's Institute in Britain is founded – at Llanfairpwll in North Wales.

1918 – Representation of the People Act gives women over the age of thirty the right to vote in elections.

1919 – Nancy Astor is the first woman to sit in the UK Parliament, as Conservative MP for Plymouth Sutton. (Constance Markiewitz had been elected an MP in 1918, but chose not to take her seat, in protest at Britain's policy in Ireland.)

1922 – Ivy Williams becomes the first woman called to the English Bar.

1928 – Equal Franchise Act gives women over twenty-one the right to vote – equal voting rights with men.

1929 – Margaret Bondfield becomes Britain's first female cabinet minister.

Labour MP for Northampton from 1923, she was appointed Minister for Labour by prime minister Ramsay MacDonald. (In 1923, she had been the first woman to chair the General Council of the Trades Union Congress.)

1930 – Amy Johnson is the first woman to fly solo from England to Australia.

1936 – Laura Knight is the first woman to be elected to full membership of the Royal Academy since its foundation in 1768. Elizabeth Cowell becomes the world's first female TV announcer, broadcasting on the BBC's fledgling television service.

1953 – Lita Roza is the first British woman to top the UK music charts, with 'How Much Is That Doggie In The Window?'

1958 – Stella Isaacs is the first woman to sit in the House of Lords, following the passing of the Life Peerages Act. Three other women peers took their seats in the Lords in the same year.

1964 – Dorothy Hodgkin is the first British woman to be awarded a Nobel Prize for scientific achievement – for Chemistry, in recognition of her work in the field of x-ray crystallography.

1965 – Barbara Castle, a Labour MP, is appointed Minister of Transport, becoming Britain's first female minister of state.

1968 – Bridget Riley is the first female artist to be awarded the International Prize at the Venice Biennale.

1970 – Equal Pay Act requires 'equal treatment for men and women in same employment'.

1972 – Rose Heilbron is appointed the first female judge to sit at the Old Bailey – one of her many pioneering achievements in the field of law.

1975 – Sex Discrimination Act protects men and women from discrimination on the grounds of sex or marital status. The Equal Opportunities Commission is set up to enforce it.

1976 – Mary Joy Langdon becomes Britain's first female firefighter upon joining the East Sussex Fire Brigade.

1979 – Margaret Thatcher, Conservative MP for Finchley, becomes Britain's first woman prime minister. Josephine Barnes becomes the first female president of the British Medical Association.

1983 – Mary Donaldson becomes the first female Lord Mayor of London.

1985 – Equal Pay (Amendment) Act allows women to be paid the same as men for work of equal value.

1986 – Sex Discrimination (Amendment) Act enables women to retire at the same age as men.

1987 – Diane Abbott becomes the first black woman MP at Westminster.

1991 – Helen Sharman is the first British woman to travel into space, visiting the *Mir* space station. (The first woman in space was the Soviet cosmonaut Valentina Tereshkova, who flew *Vostok 6* in 1963.)

1992 – Betty Boothroyd is elected Speaker in the House of Commons – the first woman to hold the position in its 700-year history. Stella Rimington is appointed the first female Director General of MI5.

1993 – Rebecca Stephens is the first British woman to conquer Everest. (Junko Tabei, from Japan, had been the first woman to climb the mountain, in 1975.)

1994 – Church of England ordains its first women priests; Angela Berners-Wilson is considered the very first, by virtue of her having been at the top of the list of thirty-two women ordained in alphabetical order on 12 March. Rape in marriage is made a crime.

1997 – Ann Taylor, a Labour MP, becomes the first female Leader of the House of Commons.

2001 – Clara Furst becomes the first woman to be appointed Chief Executive of the London Stock Exchange.

2006 – Baroness Hayman becomes the first Lord Speaker of the House of Lords. Margaret Beckett becomes Britain's first female Foreign Secretary.

2007 – Jacqui Smith becomes Britain's first female Home Secretary. Doris Lessing becomes the first British woman to win the Nobel Prize in Literature.

2009 – Carol Ann Duffy is appointed Poet Laureate, becoming the first woman, Scot and openly LGBT person to hold the position in its 400-year history.

2010 – Equality Act streamlines anti-discrimination law, superseding the Equal Pay Act 1970 and the Sex Discrimination Act 1975, among others.

2014 – Libby Lane is the first woman ordained as a bishop in the Church of England, as Bishop of Stockport.

2017 – Cressida Dick is appointed the first female Metropolitan Police Commissioner. Brenda Hale sworn in as the first female president of the UK Supreme Court.

PICTURE CREDITS

Additional commissioning and acquisition information
for images © National Portrait Gallery, London:

pp.2, 94 Given by Terence Pepper, 2003; pp.5, 67 Purchased
with help from the National Lottery through the Heritage
Lottery Fund, and Gallery supporters, 2008; p.14 Acquired
Criminal Records Office, 1914; pp.17, 20 Purchased with
help from the Gulbenkian Foundation, 1965; p.19, 23
Transferred from the British Museum, 1879; p.21 Purchased
with help from the Art Fund, the Pilgrim Trust, H.M.
Government, Miss Elizabeth Taylor and Richard Burton,
1972; p.25 Accepted in lieu of tax by H.M. Government and
allocated to the Gallery, 1988; p.28, 32, 54, 55 Purchased with
help from the Friends of the National Libraries and the Pilgrim
Trust, 1966; p.29 Purchased with help from the Art Fund, the
Portrait Fund, the American Friends of the National Portrait
Gallery in memory of David Alexander (President 2003 to
2010), Richard Aylmer, Sir Harry Djanogly CBE, the Golden
Bottle Trust, Terry and Maria Hughes, Lady Rose Monson,
Sir Charles and Lady Nunneley, Sir David Scholey CBE and
Lady Scholey, and two anonymous supporters, 2013; p.30
Bequeathed by John Neale, 1931; p.37 Lent by Paddy Barrett,
2008; p.38 Accepted in lieu of tax by H.M. Government
and allocated to the Gallery, 2011; p.40 Purchased with help
from the Art Fund, 1965; p.42 Bequeathed by Jane, Lady
Shelley, 1899; p.45 Given by Dr D.M. McDonald, 1977;
p.46 Purchased with help from the Friends of the National
Libraries, 1948; p.49 Given by members of the sitter's family
in memory of Drusilla Scott, the sitter's great-great-
granddaughter, 2013; pp.52–3 Given by Mrs George Jones,
1871; p.56 Bequeathed by the sitter's daughter-in-law, Jane,
Lady Shelley, 1899; p.61 Acquired Clive Holland, 1959; p.62
Given by Elizabeth Malleson, 1912; p.63 Given by the sitter's
son, Sir Mayson Beeton, 1932; p.66 Given by Queen Victoria,
1900; p.73 Purchased with help from the Art Fund and the
Heritage Lottery Fund, 2002; p.77 Given by Robert R. Steele,
1939; p.79 Bequeathed by Octavia Hill, 1915; p.81 Bequeathed
by Patrick O'Connor, 2010; p.83 Purchased with help from the
Art Fund, 1987; p.90 Given by Bertram Lyle Rathbone, 1959;
p.91 Given by Memorial Committee, 1929; p.97 Given by
Victoria & Albert Museum via Pinewood Studios, 1989;
p.98 Transferred from Central Office of Information, 1974;

p.102 Given by Bassano & Vandyk Studios, 1974; pp.106–7
Given by Nekbakht Foundation, 2015; pp.112–13 Given by
the sitter's sister, Jennifer Glynn, 1996; pp.114–15 Bequeathed
by Elizabeth David, 1993; p.117 Given by Women's Royal
Voluntary Service, 2008; p.141 Commissioned as part
of the First Prize, BP Portrait Award, 2002, 2005; p.145
Commissioned; made possible by J.P. Morgan through
the Fund for New Commissions, 2008; p.148 Given by
IPC Newspapers Limited, 1971

Published in Great Britain by National Portrait Gallery
Publications, St Martin's Place, London WC2H 0HE

For a complete catalogue of current publications, please
write to the National Portrait Gallery at the address above,
or visit our website at www.npg.org.uk/publications

ISBN 978 1 85514 746 1

A catalogue record for this book is available from
the British Library.

10 9 8 7 6 5 4 3 2 1

Printed in Italy

Managing Editor: Christopher Tinker
Proofreader: Kara Green
Production Manager: Ruth Müller-Wirth
Publishing Assistant: Tijana Todorinovic
Designer: Peter Dawson, www.gradedesign.com

Caption texts written by Helen Armitage
and Kathleen Bloomfield

Dimensions expressed height x width (mm)

ACKNOWLEDGEMENTS
The National Portrait Gallery Collection has grown
through the generosity of many institutions, families and
individuals who have donated important works. Equally
important has been the support over many decades of the
Art Fund (formerly known as the National Art Collections
Fund), and in more recent years of the National Heritage
Memorial Fund and the Heritage Lottery Fund. The
Gallery's own Portrait Fund has become increasingly
significant, and the National Portrait Gallery is very
grateful to all those who have supported the Fund as well
as the public campaigns to acquire particular portraits.

FSC
www.fsc.org

MIX
Paper from
responsible sources
FSC® C015829